FANTASY LIFE

★ ★ ★

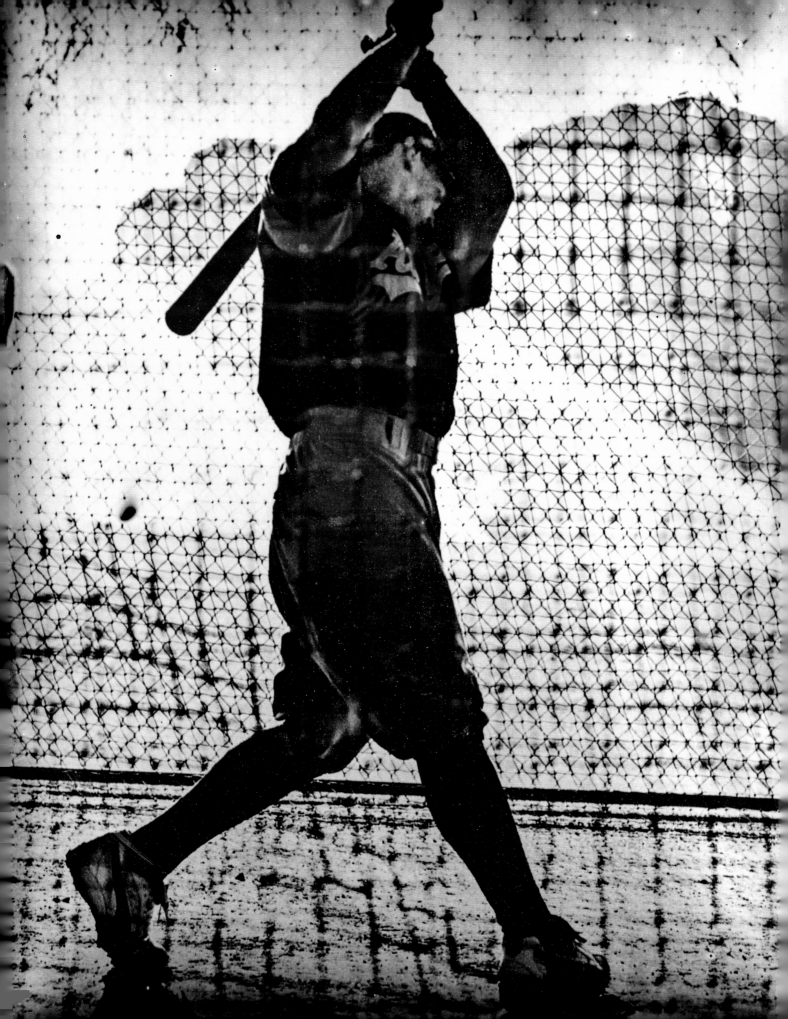

FANTASY LIFE

PHOTOGRAPHS BY
TABITHA SOREN

FIVE LINKED STORIES BY
DAVE EGGERS

BASEBALL
AND THE
AMERICAN
DREAM

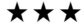

WITH COMMENTARIES BY
JOE BLANTON, JEREMY BROWN, DREW DICKINSON, BEN FRITZ,
MARK KIGER, STEVE OBENCHAIN, CHRIS SHANK, BRIAN STAVISKY,
NICK SWISHER, AND MARK TEAHEN

aperture

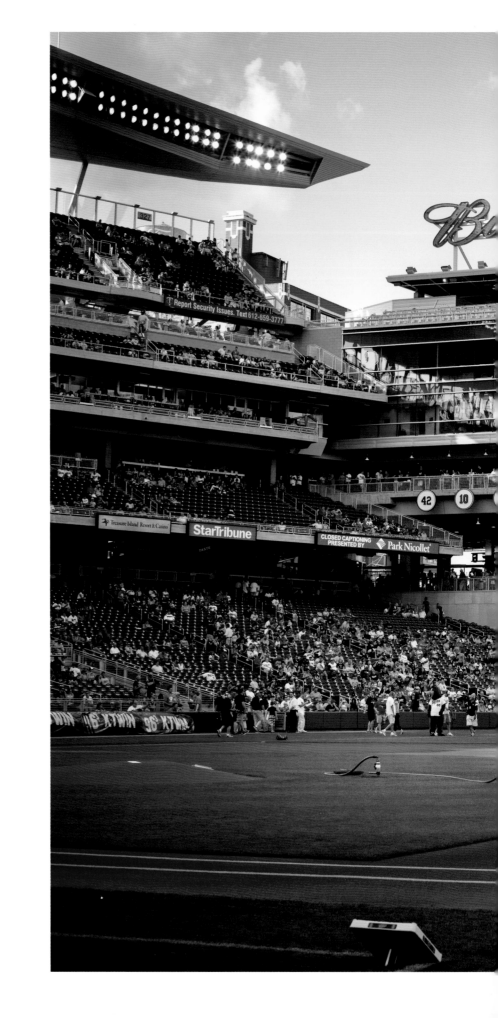

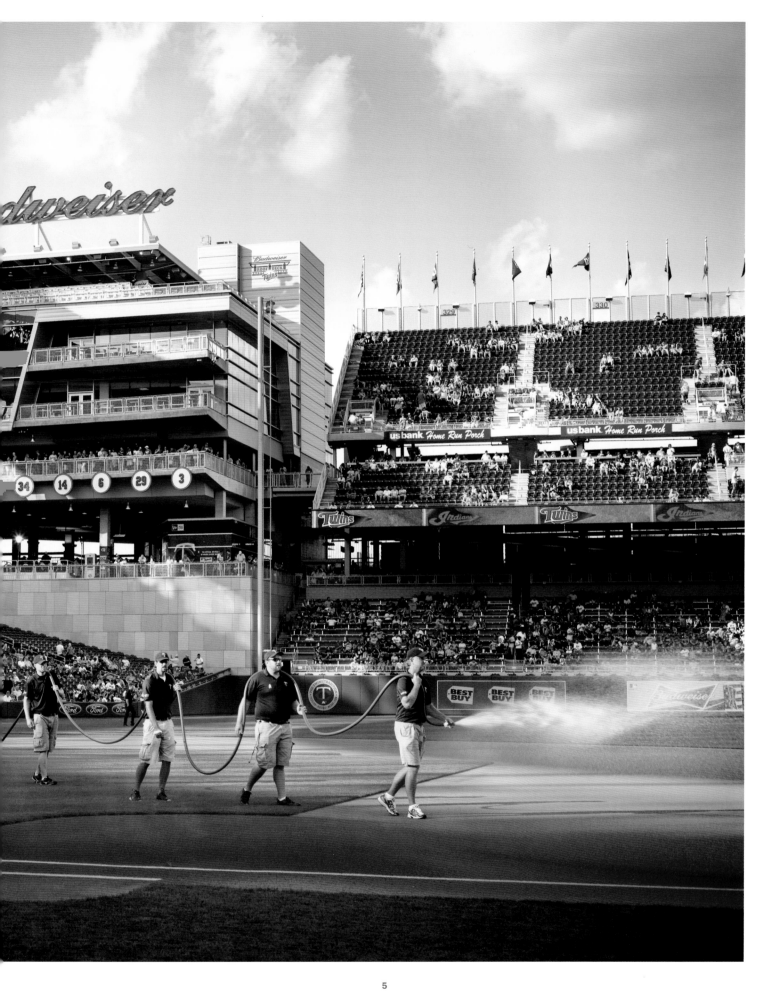

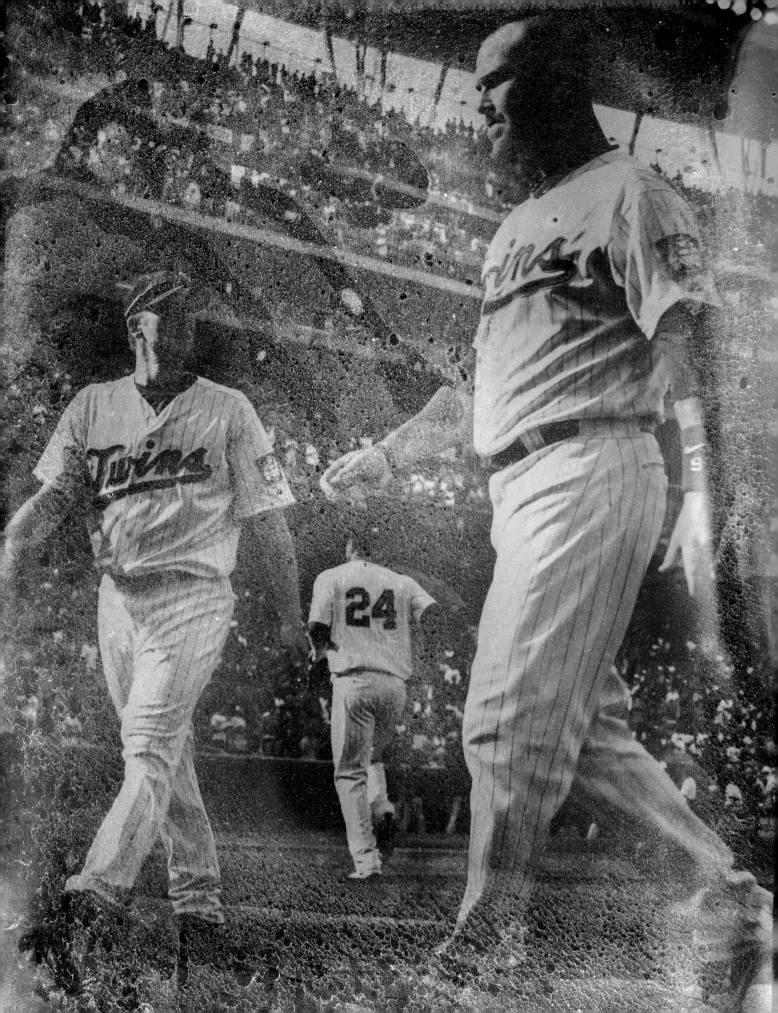

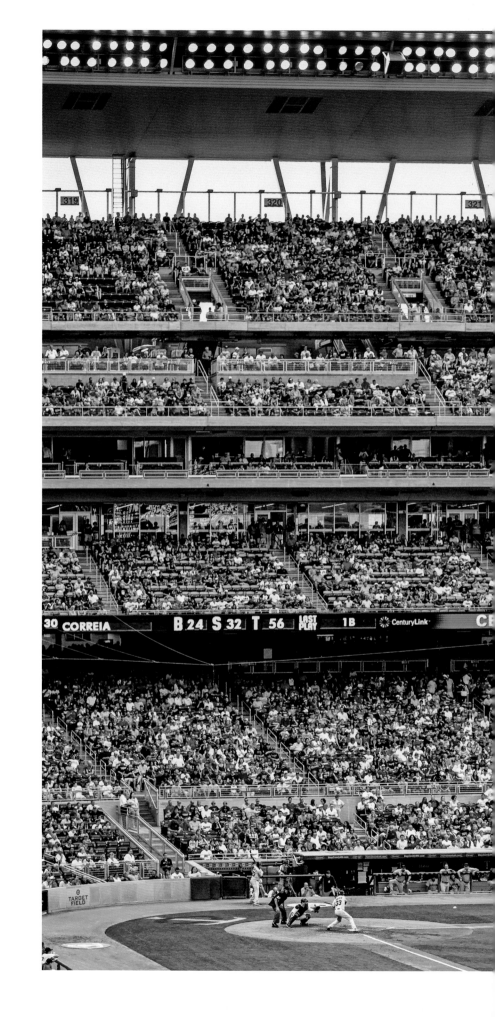

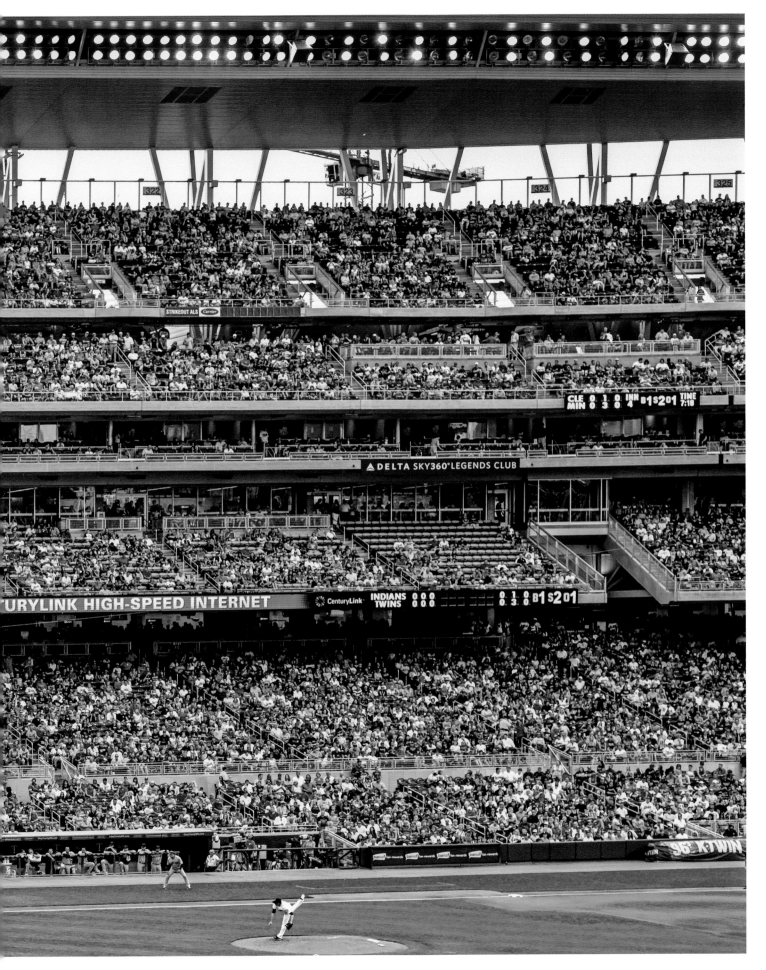

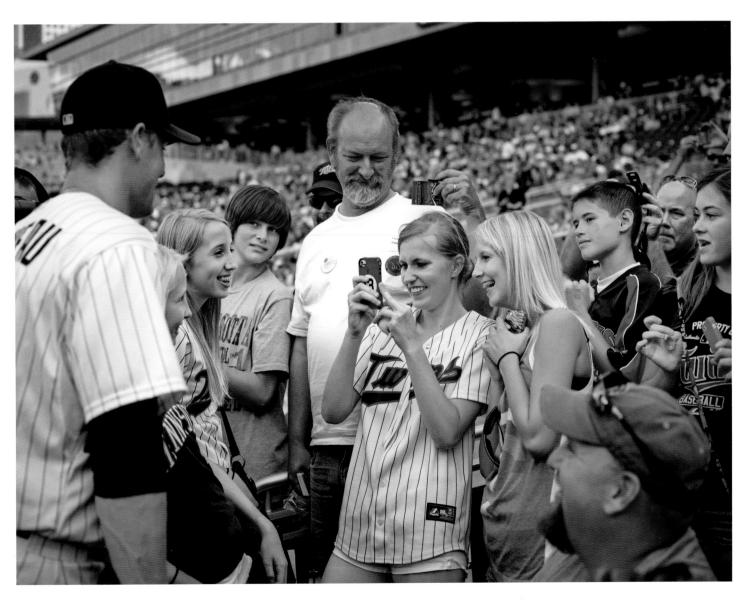

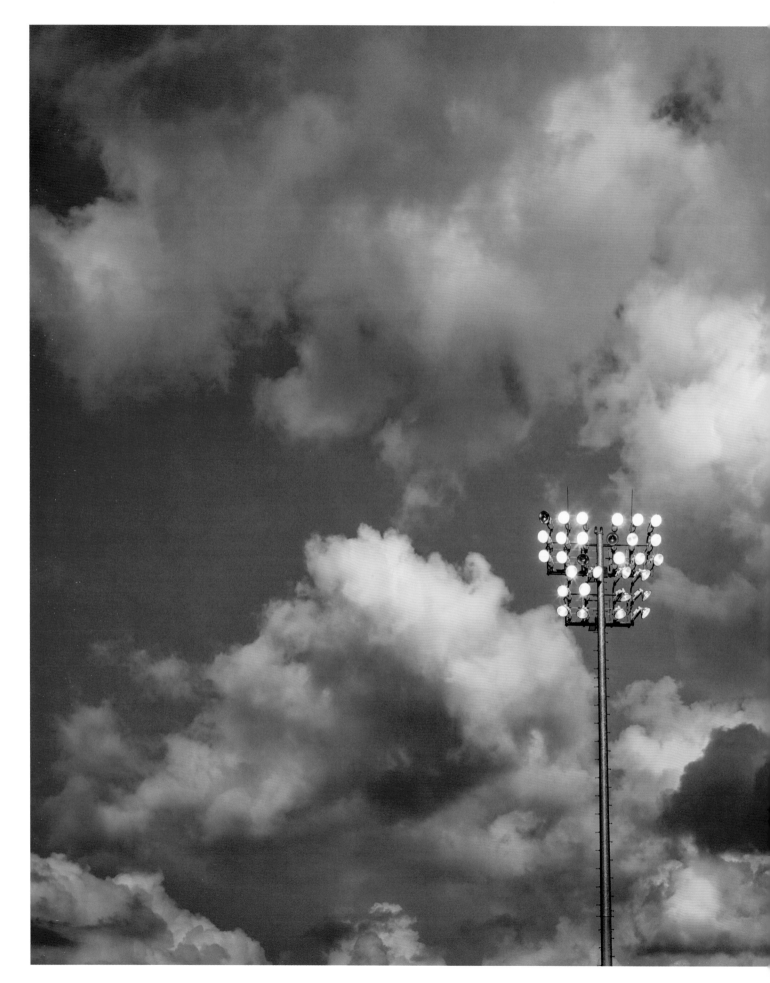

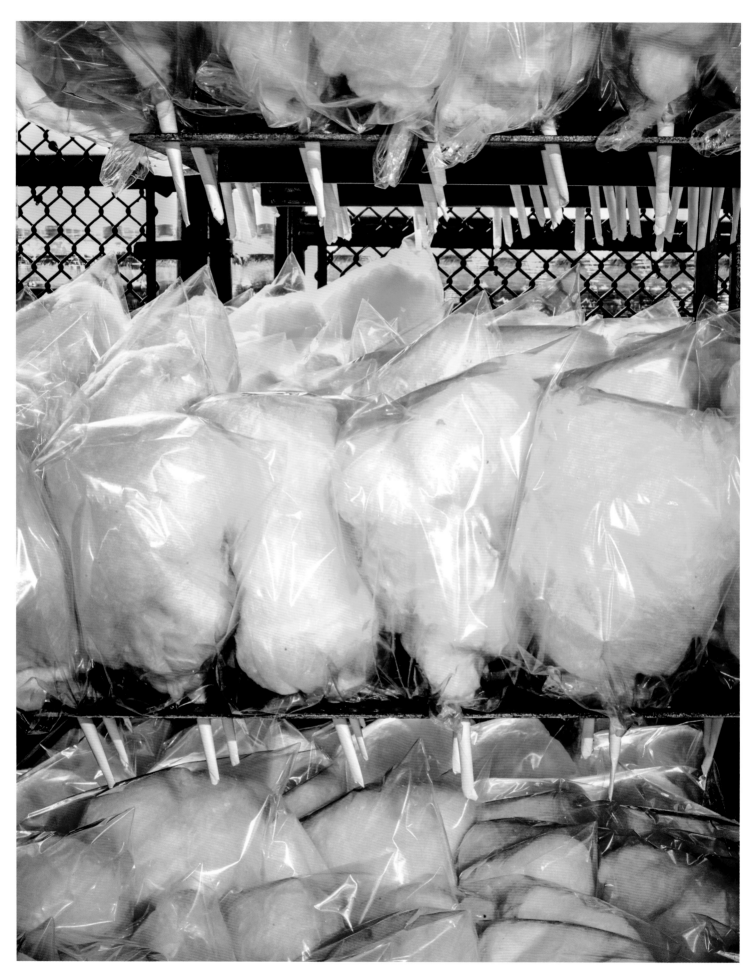

1:

YOUR NAME IMPLIES A MAN WITHOUT GUILE...

He was born Giovanni Fillipacci but by middle school everyone called him Gee. By the time he was eighteen, he was tall for a second baseman, six-two and two-ten, with opposite-field power. He hit forty-one homers in his senior season, with thirty walks and only twelve strike-outs. That kind of patience and power got a player noticed.

He was drafted by Kansas City and sent to the Idaho Falls Chukars. *Chukars.* He had to look that up. It sounded like a kind of South Asian vegetable, but it was actually a local bird, the kind hunted for sport.

He flew into Boise and caught a bus to Idaho Falls. It was a pretty state, he thought. Almost empty of people. Mostly hills and sky. He was met at the bus station by the equipment manager, a laconic man in sagging jeans who introduced himself as Jenkins.

"Your name implies a man without guile," he said to Gee. Gee smiled and made a point to look up *guile.*

In his Lincoln Continental, twenty years old but immaculate, Jenkins took Gee around town, getting him oriented, buying him some Jack in the Box. They discovered they both had military fathers who were at once absent and unforgiving. They'd both seen *The Great Santini* once and once was enough.

Eventually they arrived at a bridge over a wide canyon.

"That's the waterfall," Jenkins said drily. "And we're in Idaho. So you can see where the place gets its name."

For the first few months, Gee was just happy to be there. He even used that phrase, "Just happy to be here," a few times, maybe more, until Mike McGeoghan, a thirty-year-old pitcher they called Gandalf, told him to *Stop the fuck saying that.*

Otherwise, the veterans were good to him. At nineteen, Gee was one of the youngest, and everyone knew that, so they called him Babe. Then Babe the Blue Ox, then Ox, and sometimes Blue. Then Blue Boy. Then Little Boy Blue. Then LBB. Then OPP and LBJ. After a few weeks some of the guys on the team, especially the Latino players, had no idea what Gee's real name was. This was the subject of discussion one night, in front of Gee, when they were in extra innings against Grand Junction.

"This much I know," Ravenswood said. "His first name begins with *G.*"

No one cared, really, especially given Gee wasn't hitting. When he'd arrived, Gee didn't expect to be in Idaho long. Some scout had rated him the best second baseman prospect in the Pioneer League, so he spent the first season with the Chukars a little high on his own fumes. In his first month he'd only made three errors, but he was striking out a lot, chasing garbage. He was an easy out. He was hitting .231.

★ DAVE EGGERS ★

17

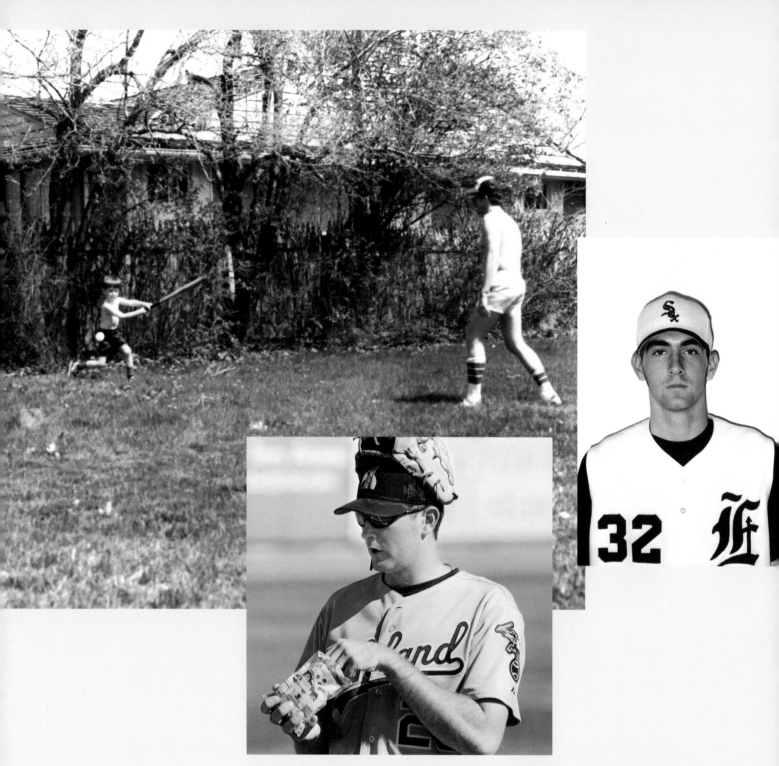

STEVE OBENCHAIN (b. 1981)

Most guys in the minors don't make it to the big leagues, and a portion of those that do get a cup of coffee, and that's it. As a kid, I was going to win Game Seven of the World Series. I was going to have a nice, long career throwing a baseball. The older I got, and the closer I got, the more reality set in. It's easy to be the best kid on your Little League team and the youth leagues. Still pretty easy to be a top guy on your high school team. College is a collection of all of those guys. You

Position: Pitcher
Drafted: 2002, 1st round (37th pick) by the Oakland A's
Years playing baseball: 24
Seasons in minor leagues: 5
Seasons in major leagues: 0
League earnings: Undisclosed
Current career: Supervisor of Portfolio Support Services, Donaldson Capital Management, Evansville, IN
Marital status / children: Married / 5

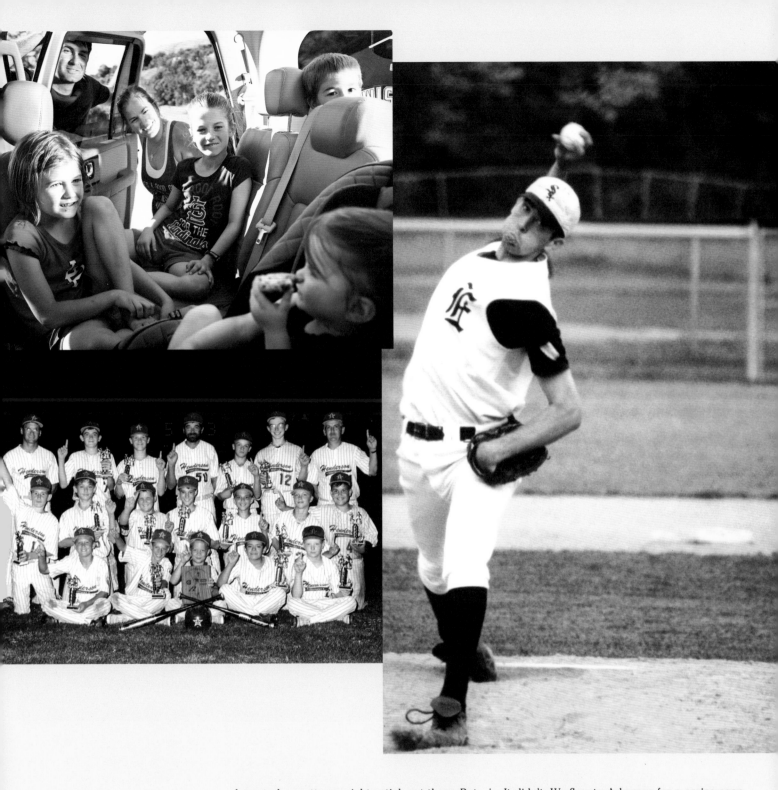

have to be pretty special to stick out there. But once you're a professional, and it's the absolute best baseball players in the world, and they're all fighting for the same spot you want, it starts to hit you that "maybe I'm not good enough."

I threw a pitch in the second inning of a game on Memorial Day in Midland, Texas. I felt a pain I had never felt in my shoulder. I ended up getting through five innings before I couldn't fight it anymore. I asked to be taken out. I iced my shoulder like normal, hoping the pain would go away.

It didn't. We flew to Arkansas for a series soon after. My shoulder was throbbing and aching the entire time. When we got back, I was diagnosed with shoulder tendinitis. I finally had surgery at the end of the year. But I was never the same. I lost velocity. I lost range of motion in my arm. I lost my ability to throw on back-to-back days. I wasn't the same pitcher I was before my injury. I was damaged goods. I wasn't the same pitcher Oakland drafted. And they run a business. I totally understand why they released me.

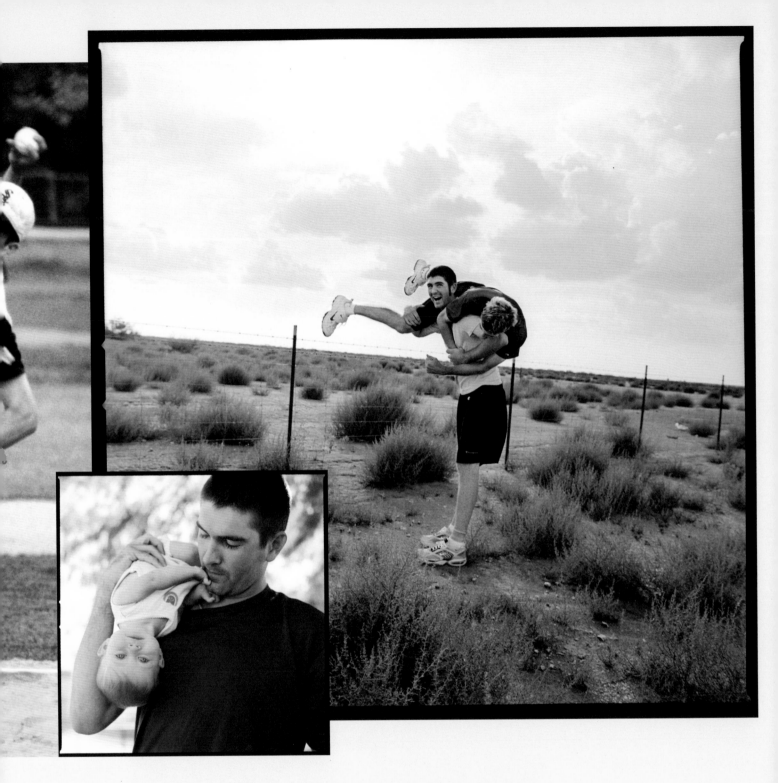

Doesn't mean I have to like it. But I understand it.

I guess you could say I fell out of love with baseball for a few years after I left the game. Going to games or watching on TV brought back all those questions. Now watching my son begin to play baseball is rekindling that love of the game. Seeing those young kids just discovering the game; how to field, throw, hit, slide. How to win as a team. I want my son to have that same love I had for sixteen years or so. And I guess, in a weird way, I want the game to break his heart, too. That means at some point, he cares passionately about it. And baseball will eventually pass him by. He will either become too old, get hurt, or just simply not be good enough. I hope he walks away because he's too old. The other two options suck. ★

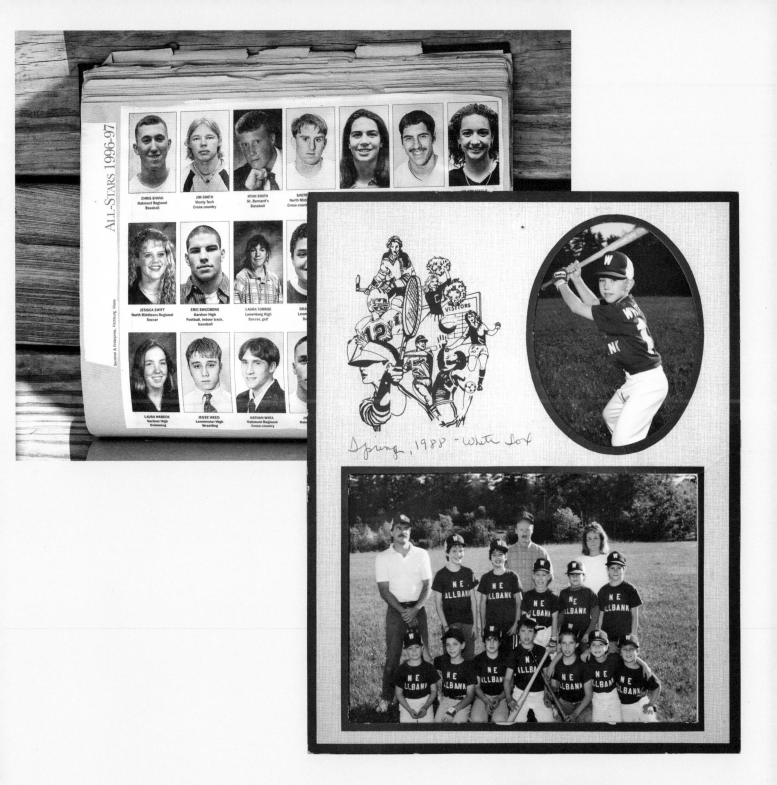

CHRIS SHANK
Oakmont Regional
Baseball

JIM SMITH
Monty Tech
Cross country

RYAN SMITH
St. Bernard's
Baseball

SHER
North Mid

HILARY STEELE

JESSICA SWIFT
North Middlesex Regional
Soccer

ERIC SWEDBERG
Gardner High
Football, indoor track,
baseball

LAURA TORRISI
Lunenburg High
Soccer, golf

BRA
Leom
Ba

LAURA WARECK
Gardner High
Swimming

JESSE WEED
Leominster High
Wrestling

NATHAN WITA
Oakmont Regional
Cross country

JI
Oak

Sentinel & Enterprise, Fitchburg, Mass.

Spring, 1988 – White Sox

CHRIS SHANK (b. 1981)

Position: Pitcher

Drafted: 2002, 23rd round (26th pick) by the Oakland A's

Years playing baseball: 21

Seasons in minor leagues: 4

Seasons in major leagues: 0

League earnings: Undisclosed

Current career: Head baseball coach, New England College, Henniker, NH

Marital status / children: Married / 2

Career highlight: 30⅓ consecutive scoreless innings for Vancouver Canadians in 2002

My dad would put a baseball in my left hand in my crib with hopes of making me a left-handed pitcher. It didn't work.

I played third base in college and started on the mound, sometimes on two days' rest after throwing 130-plus pitches. I remember my mom saying, "What are you going to do if that doesn't happen? I just don't want you to be disappointed." I couldn't believe that. That's not how I operated. The only question was what round

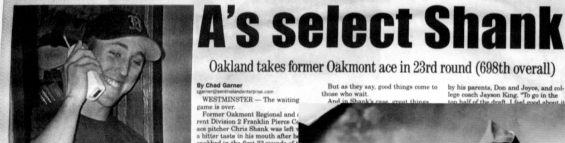

SENTINEL & ENTERPRISE

THURSDAY, JUNE 6, 2002

A's select Shank

Oakland takes former Oakmont ace in 23rd round (698th overall)

By Chad Garner
cgarner@sentinelandenterprise.com

WESTMINSTER — The waiting game is over.

Former Oakmont Regional and current Division 2 Franklin Pierce College ace pitcher Chris Shank was left with a bitter taste in his mouth after being snubbed in the first 22 rounds of the 2002 Major League Baseball First-Year Player Draft on Tuesday.

Chris Shank, who was drafted by the Oakland Athletics in the 23rd round of the Major League Baseball First-Year Player Draft Wednesday, gets the news by phone from A's scout Tom G...

But as they say, good things come to those who wait.

And in Shank's case, great things...

by his parents, Don and Joyce, and college coach Jayson King. "To go in the top half of the draft, I feel good about it...

SENTINEL & ENTERPRISE / CHAD GARNER

Former Spartan star finding success beyond high school

By JOHN MARGARITIS
Sports Correspondent

RINDGE, New Hampshire — After an off-the senior season during the spring of 1999 at Oakmont Regional High School, Chris Shank has seen even better competition than the Mid-Wach II loop in his baseball travels since then. The former Spartan ace has responded to the challenge, getting even better on the diamond.

After a highly successful summer of '99 with the North County Legion squad, Shank entered Jayson King's program at Franklin Pierce College in Rindge, New Hampshire, and proceeded to set a school record with wins, emerging as one of the top freshmen in the New England Collegiate Conference (NECC) in 2000.

Twirling in King's number two starter, Shank went 7-4 with one save and an earned run average of 2.82, and also showed his versatility by logging 27⅓ with 71 RBI as a third baseman when he wasn't pitching.

King, who took over the program two years ago with a goal of attracting top Central Mass. players, saw Shank, along with a UMass contingent of Scott Loiseau and Mike Callahan of St. Peter-Marian and Dan Close of Leominster help lead the Ravens to their first postseason invitation since the program went from NAIA status

...Shank
continued from page 9

It was also Franklin Pierce's first winning season in the NECC, a school record set with wins.

The Ravens are a school record five wins in a season (23) and set of tied nine other individual or team records, while enjoying their first winning season since 1988.

In the ECAC Division II tournament in Oakdale, New York, Shank hit a two-run homer run to force extra innings in the first game against top-seeded Dowling College, and carried a shutout into the sixth inning on the hill.

Shank's successful freshman campaign has earned him the invitation to play in the Northeast Collegiate Baseball League this summer, where he is presently playing for the Watertown (New York) Wizards, an elite wooden bat league.

"Chris had a great year on the mound for us," said FPC coach King. "He has a lot more room to progress in the field than on the mound, but I feel he is going to be even better next year at bat and at third base. This year he was one of the best pitchers in the league and I look for him to improve even more in the years to come. I think this summer in the wooden bat league he'll learn more about hitters and he an even better pitcher next year."

the year and hopefully I'll be better next year."

Shank got the invitation to Watertown after someone home bleed signed a letter to accept an opening in the prestigious Cape Cod League, opening a slot for the former Spartan.

After climbing the ladder of success from Oakmont to the Legion to FPC, Shank always enjoyed seeing the talent in the Northeast Collegiate League brings him back to reality, but the challenge only inspires him to work harder.

"There's so many good players," Coach King said it was the fine, best college summer league in the country," added Shank. "But it tells me that I have to keep going and working hard because everybody else can play."

His former high school coach Gary Cassette, feels that Shank's progress comes from his love of the game.

"He was an outstanding player, but he also was a kid that took the game seriously," said Cassette. "He dominated his senior year and he accomplished as his first year on the collegiate level.

"He had an unbelievable year on the mound," said King. "I knew he was going to be good, but it's tough to think that a freshman would do what he did. He's just dependable. He's a competitor more than anything — he's got a lot of confidence. He challenges hitters and he's a smart pitcher — you don't see that too much. Shank should have been the Rookie of the Year in the conference, but he got dipped from my perspective.

Sports

Sentinel & Enterprise

Sports Editor:
Kevin O'Malley
Phone: 343-6911, ext. 274
Fax: 342-1198
E-Mail: sports@sentinelandenterprise.com

Shank, Close exceed all expectations at FPC

Former high school stars make mark as freshmen for Ravens

By Chad Garner
Staff Writer

When Franklin Pierce College baseball coach Jayson King recruited former Oakmont Regional star pitcher/shortstop Chris Shank and Leominster pitcher/outfielder Dan Close, he knew the duo would obviously help out the Ravens program.

But he just couldn't believe how much they actually did helped in their freshman season.

"They were both toward the top recruiter," said around-year coach King. "They got some scholarship money, but they did more than I expected they would do. As a whole I was happy with both of them. They both have good ability, and they proved what they can do in the future. But I expected them to have good years. They both work hard and they want to improve — they're dedicated kids."

Shank, a fiery competitor on the mound, at the plate and in the field, earned the New England Collegiate Conference (NECC) upside down — especially on the hill. Shank posted a team-high seven wins — the most ever at Franklin Pierce College and posted a 2.82 ERA — tops in the conference. At the plate, Shank belted .271 with 21 runs, 36 hits, two home runs, six doubles, 21 RBIs, and six stolen bases. Add three Rookie of the Week honors in the NECC, and Shank proved to be a top-notch recruit.

"I knew I had the potential to pitch well. I think I threw the ball as well as anybody in the league — in my ERA proved that," said Shank, who recently signed on to play with Close for the Watertown Wizards, a wooden bat league in Watertown, N.Y. "I don't think I could have done much better, but I think I could have pitched a little better to

as a relief. In the starting rotation, I think I did pretty well. I'd like to continue to pitch well and hopefully get drafted. I just want to continue to do what I've been doing since I've been five years old and try to play the game as hard as I can."

King is simply armored with what Shank accomplished in his first year on the collegiate level.

PEOPLE ARE 'RAVEN' — Former Oakmont Spartan and current Franklin Pierce College baseball player Chris Shank had a tremendous freshman season for the Ravens.

Former Oakmont Spartan Chris Shank, left, and former Leominster Blue Devil Dan Close give Ravens fans much to talk about after posting stellar rookie seasons this spring.

See CLOSE, Page A10

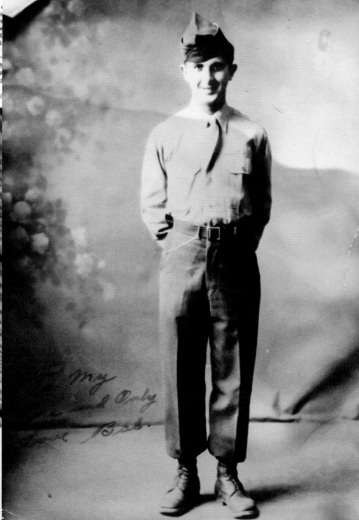

My
and only
Bill

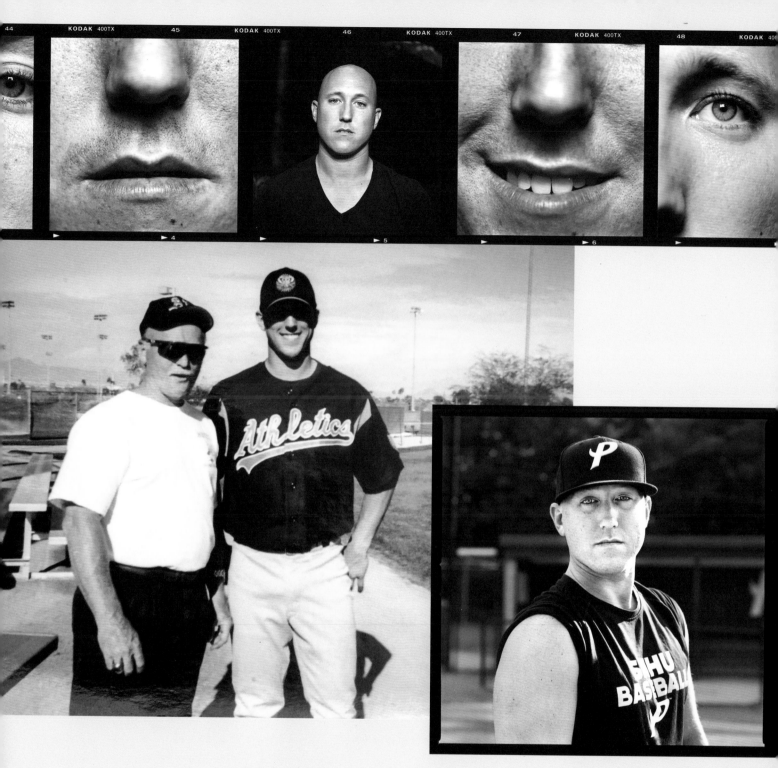

would I be drafted and by who? Here I was, an 86-mph, 6-foot, 185-pound stocky right-handed pitcher going into the winter months leading up to my junior year and getting drafted wasn't up for debate!? I was insane. However, I used my mother's doubt as fuel and made myself into a real prospect in just three months. All of a sudden I was throwing 92 mph and weighed 195 pounds. You can imagine what that did to my already-inflated view of myself. I threw a no-hitter on opening day and the rest is history.

Oakland selected me in the twenty-third round. My family, myself, Coach King, and a small amount of media were huddled in my bedroom when the call came in. I was overwhelmed with joy. My mother was sitting in a rocking chair in the door-way. I just bent down, embraced her, and we both just cried. ★

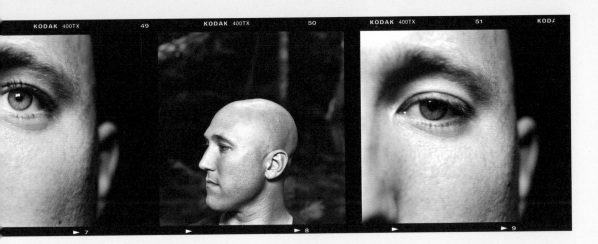

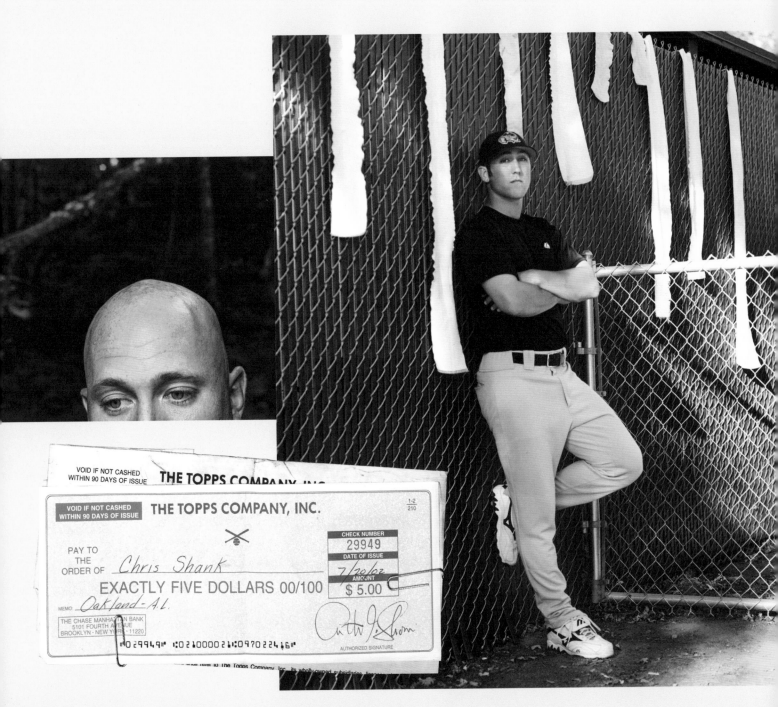

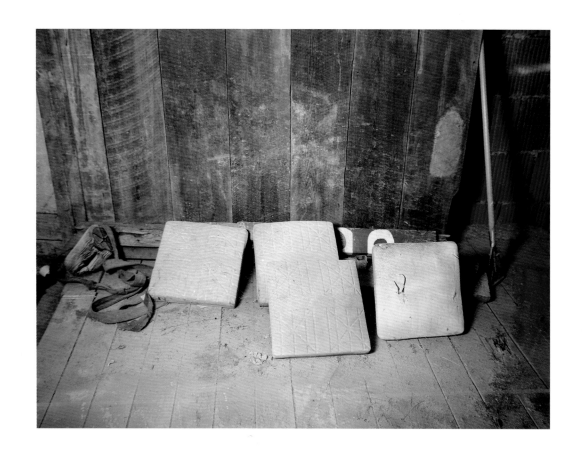

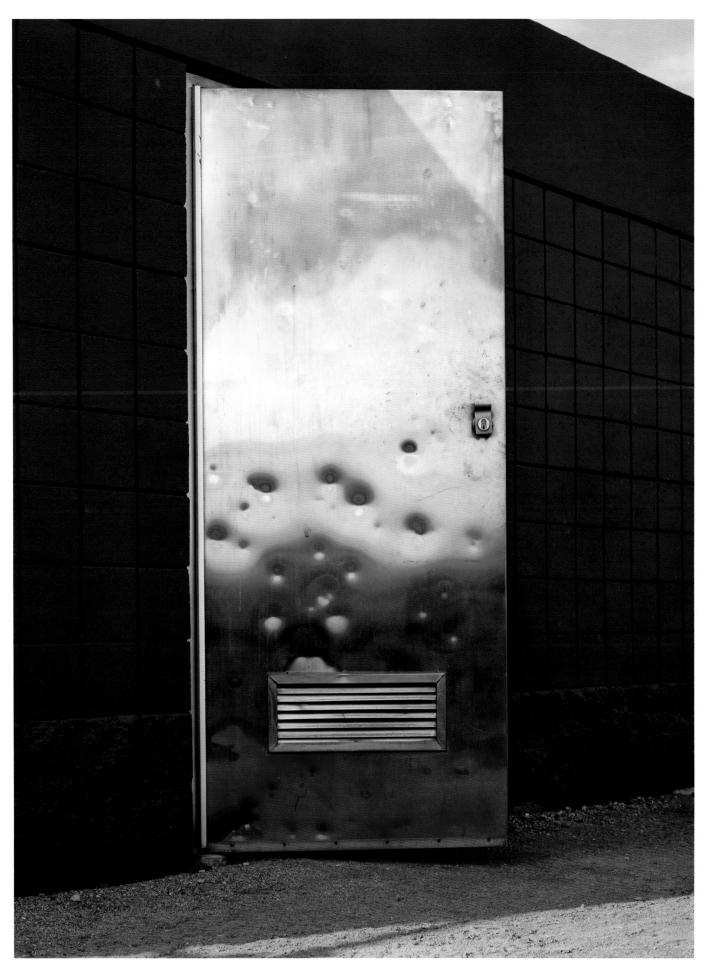

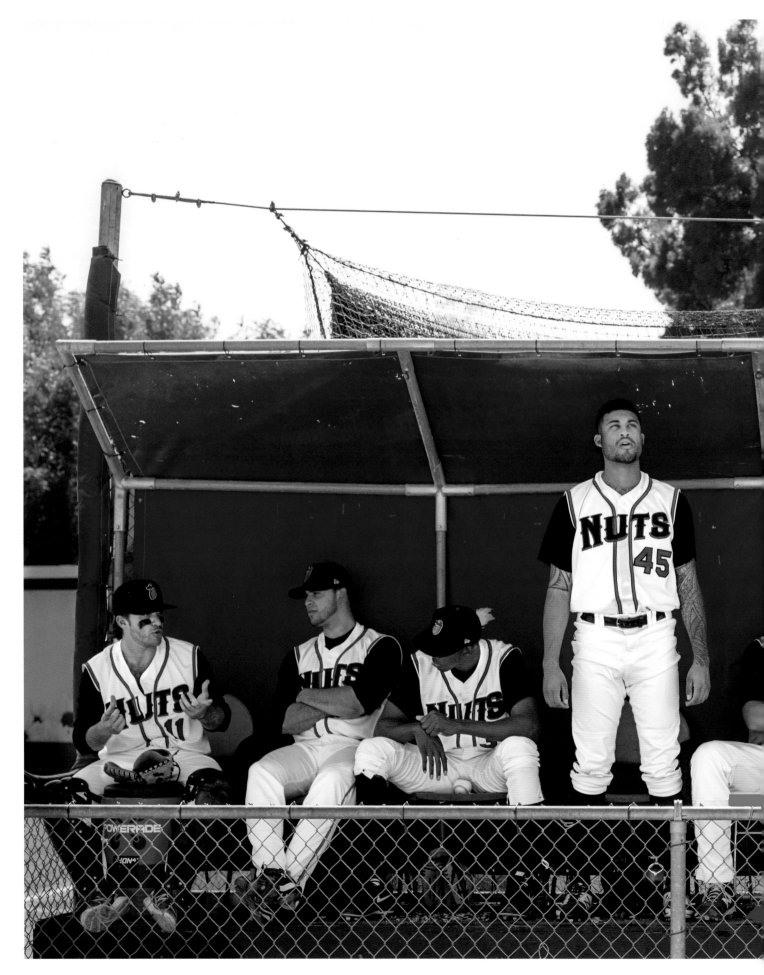

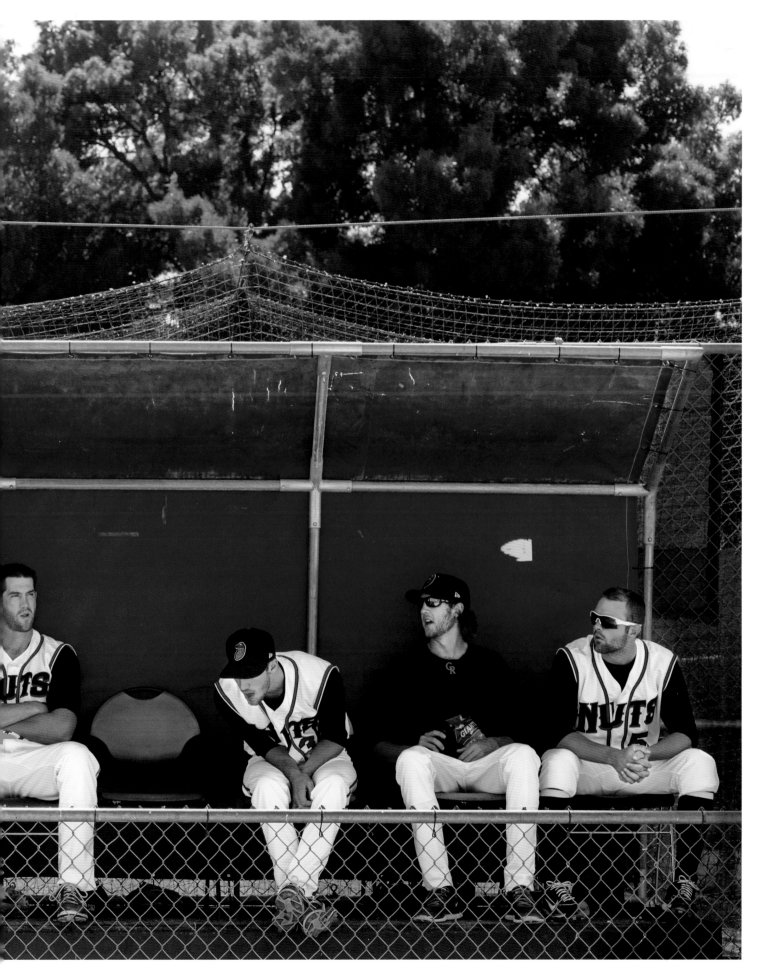

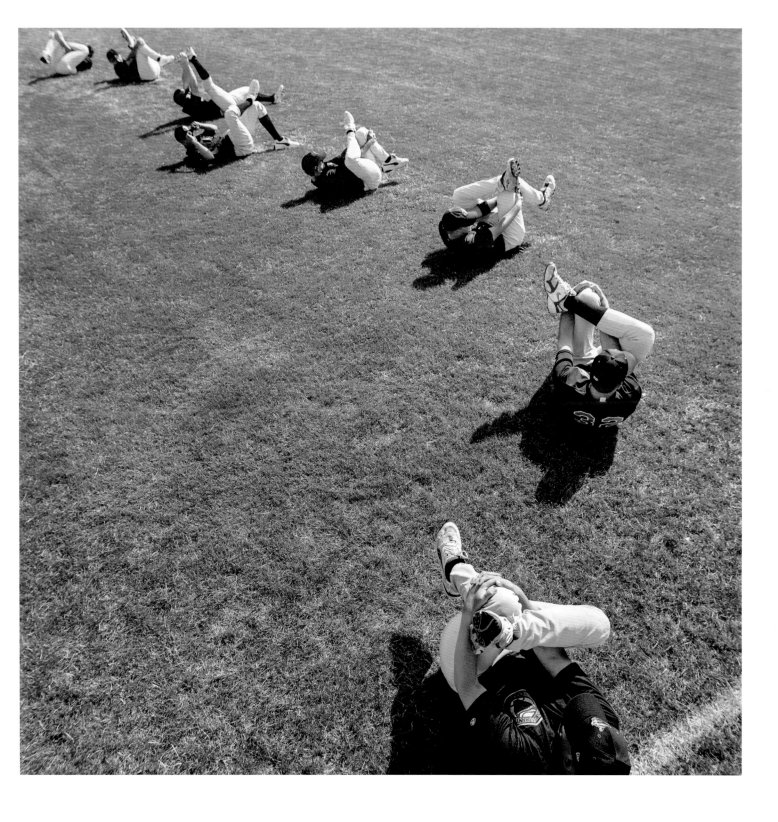

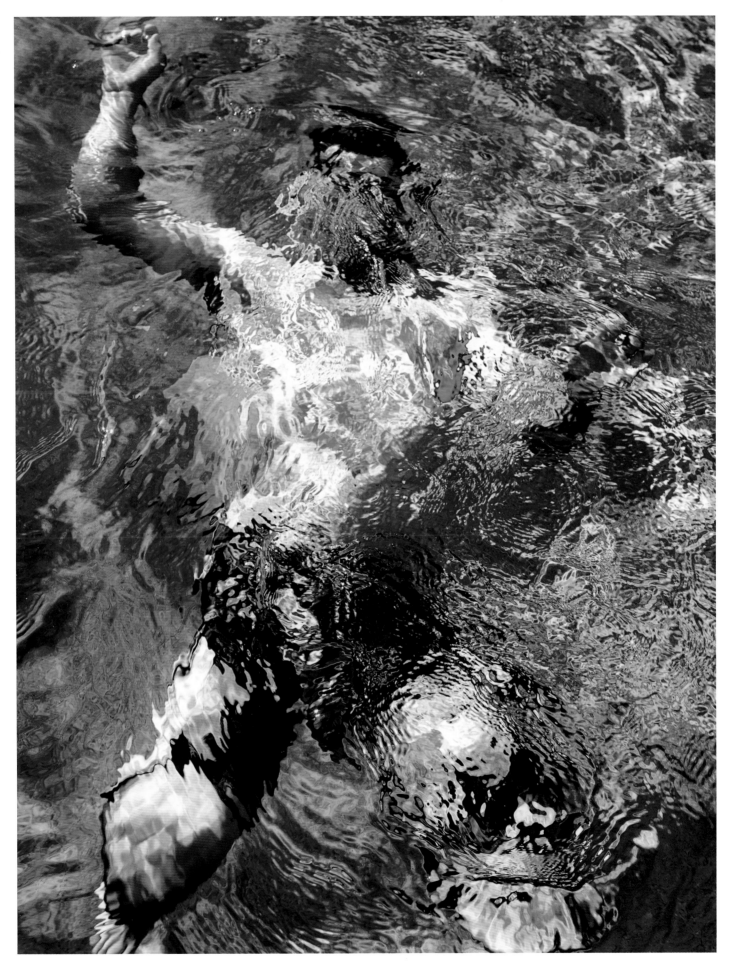

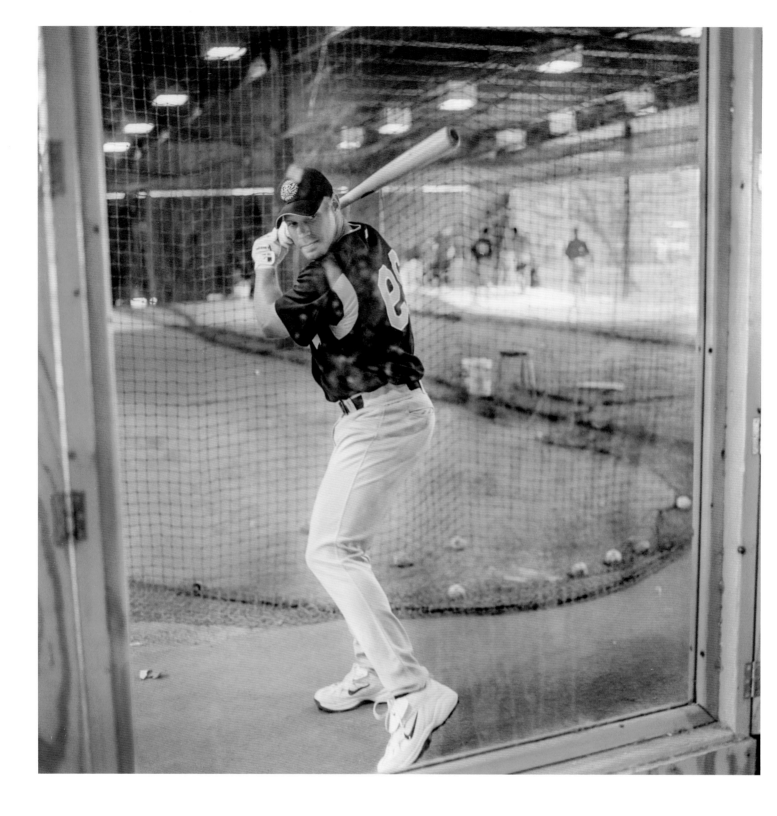

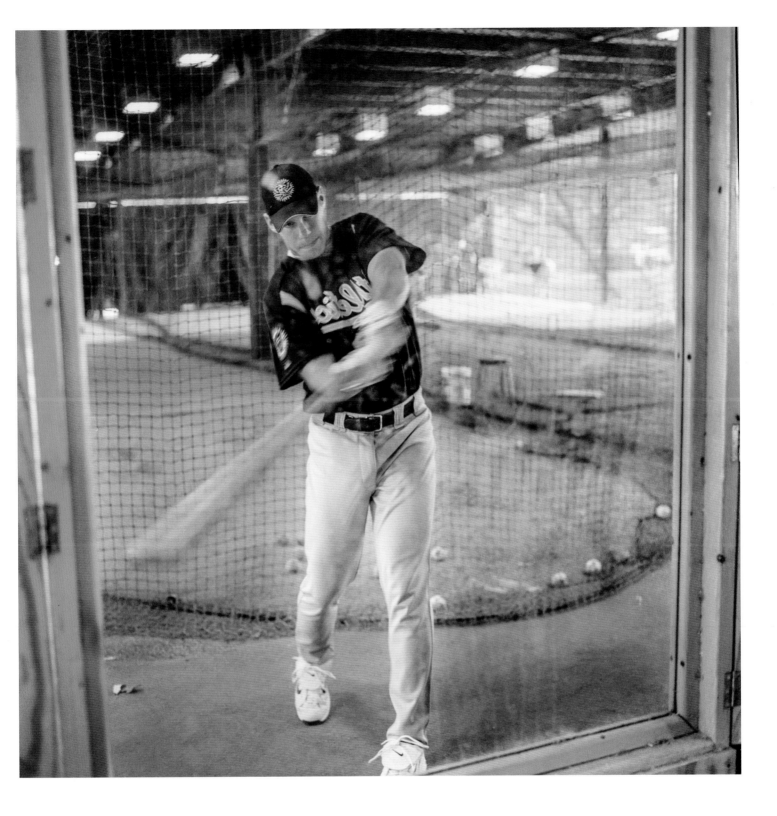

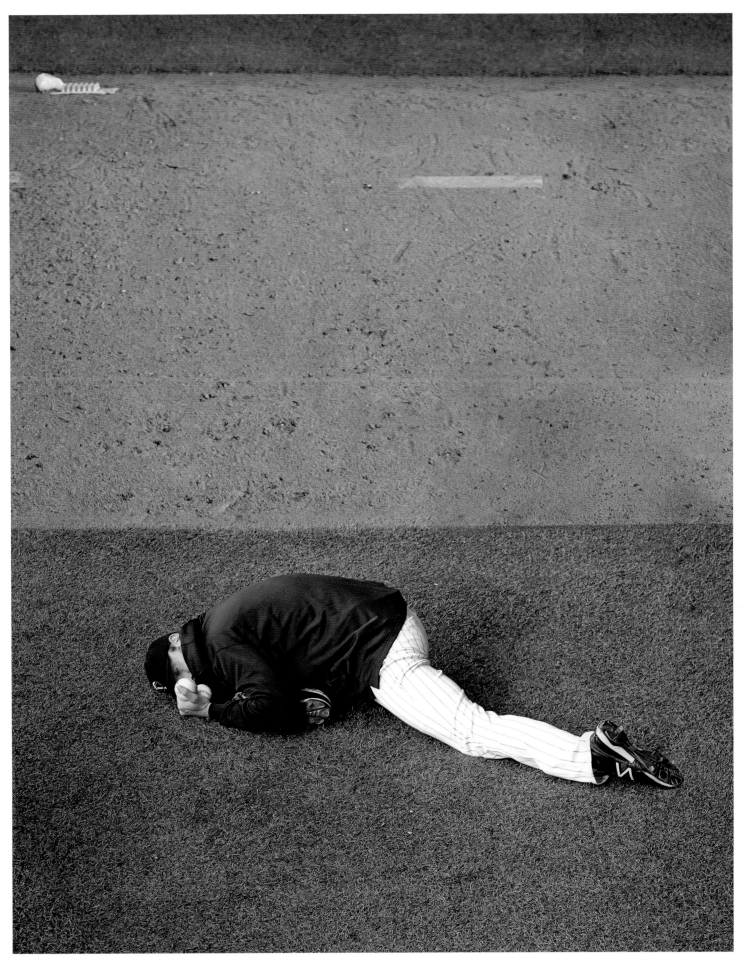

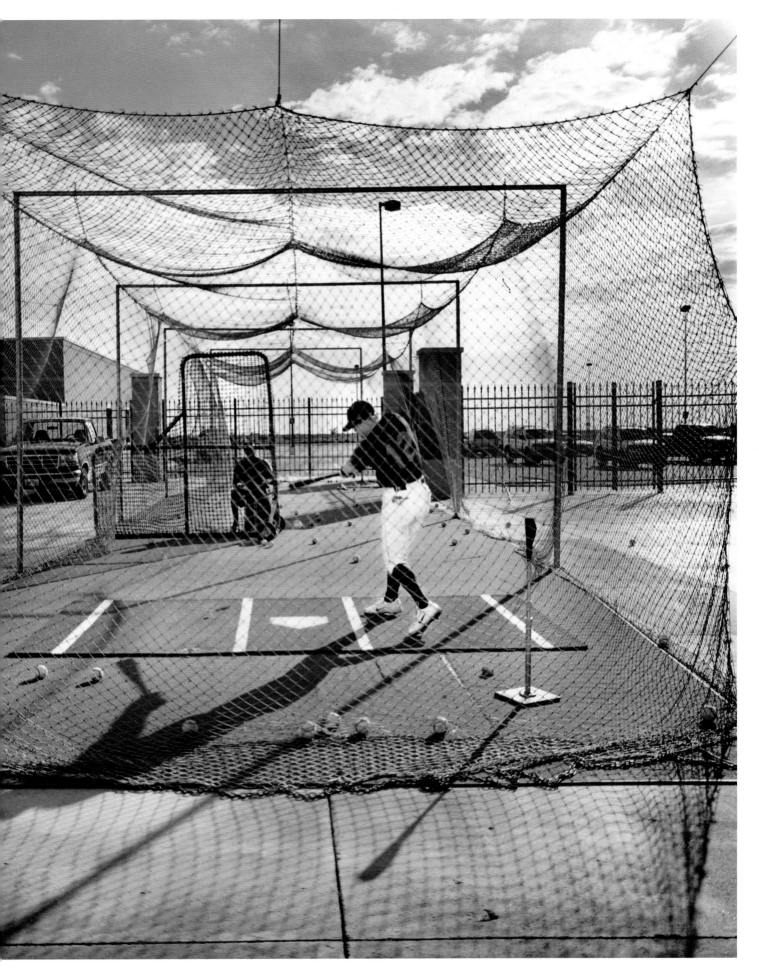

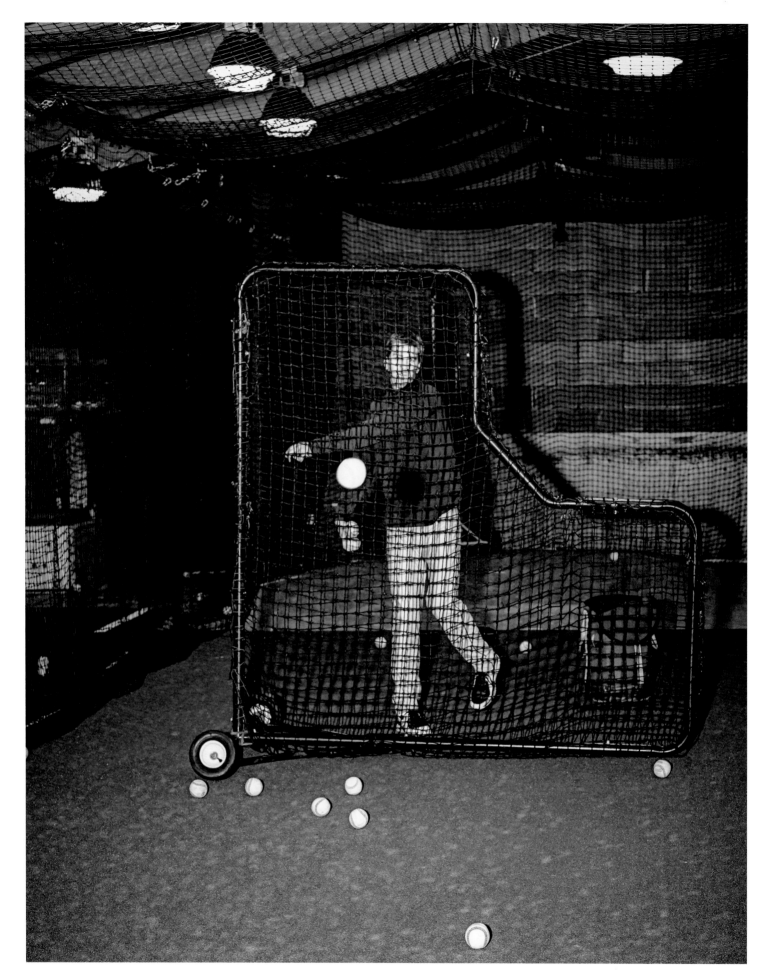

The screaming had to be real. It was too tormented to be fake.

Gee needed to be thinking of Missoula's relievers, who they might be putting in the sixth or seventh, when he might get a chance to pinch-hit. Second base, this day, was being played by a major leaguer, Tommy Porchovsky, rehabbing from a minor toe sprain. So at best Gee would hit for the starting pitcher. And he had to hit. His situational batting had fallen off a cliff. He did fine with no one on base, did nothing when it mattered.

So he had to think about this, but all he could think about was the strangled wails coming from the announcer's booth between innings.

Ryan Schulte, the play-by-play guy, was having his back hair waxed off. In the middle of a game. The team's marketing department's funny idea. Someone had taken a picture of Schulte at the community pool a few months earlier, and it had been blown up, posted on the locker room bulletin board since. His extravagant back hair was a source of constant fascination.

"Notice how *long* the hair is," Jenkins noted one day, standing before the picture like he would a work of art. "See how it's swept across his shoulders, as if carefully brushed that way. Like a combover for his back. Remarkable."

Every year the local Boys and Girls Club got someone to shave his or her head for money, and this, the waxing of Schulte's back, was apparently the logical next step. The night's promotion invited fans to "Experience the Sounds of Baseball, and Back Waxing." The attendance was a record for a mid-season game. Schulte was in the booth, calling the game, and in between innings—they had two microphones set up, one right up against his back, the other by his mouth.

"It really puts you in the action," Mountmorris observed.

The crowd was loving it. The tape would tear, Schulte would yelp, the fans would cheer. How this was baseball, Gee had no idea. The minors were a bizarre double helix of young men's most fervent and long-dreamed dreams wound into candy-coated nonsense—dancing mascots and promotions so silly they'd embarrass a Kentucky carnie.

Another scream from the booth.

"I do believe that man might die," Jenkins said.

For Gee, after three years, it was still fun. But a bit less fun. The clock was ticking. Gee was twenty-two now, almost twenty-three. He was still in Single-A, which meant something. Not everything, but something. As for the majors, there were the guys who went straight from Single-A to the show, but they were rare. Gee needed to get to Double-A, then Triple-A, and soon. Twenty-three was a fine age to get pulled up, the right age, but next year would be less right, and the year after that, it would start seeming too late.

We're ice cubes in the sun, McGeoghan once said to Gee. *Melting slowly and without the—*

Got it, Gee had said.

But tonight, at least, they would eat well. After the game, Porchovsky was keeping Outback Steakhouse open and treating the team to dinner. This was tradition. Once a month, maybe once every six weeks, some major leaguer would come down here to rehab, spend a few days, a few weeks in Idaho Falls, and before he left, custom dictated that he treat the team to dinner. Porchovsky had been taking innings from Gee for two weeks, so it was the least he could do.

The games ended around ten, and there were only a few options for a late dinner—Wendy's, Taco Bell. Maybe the concession stand had some food that could be reheated. Gee usually went home to make pasta on his neighbor's stove. Then there was 7-Eleven; the pizza there was getting better.

But this, a real dinner, steak and potatoes and beer, fresh vegetables—Gee could savor this. The team would eat and drink merrily courtesy of Porchovsky and his three Gold Gloves, the $12 million coming his way that year alone. And as they ate, they would, every last man on the team, sneak a glance or two at Porchovsky, eyeing him with perfectly uncomplicated admiration.

But that would happen later.

Another scream came from the booth. There was something raw and disturbing about the sounds being so roughly amplified—first the shock of the hair being violently ripped from its roots, and, second, at the end of Schulte's scream, the whimper of a tired man who knew more agony was coming, and soon.

Jenkins looked up to the booth, as if expecting Schulte to throw himself out and onto the crowd below. When he didn't, Jenkins returned his gaze to the field, where the pitcher was adjusting his cup.

"God bless this tragic circus," he said.

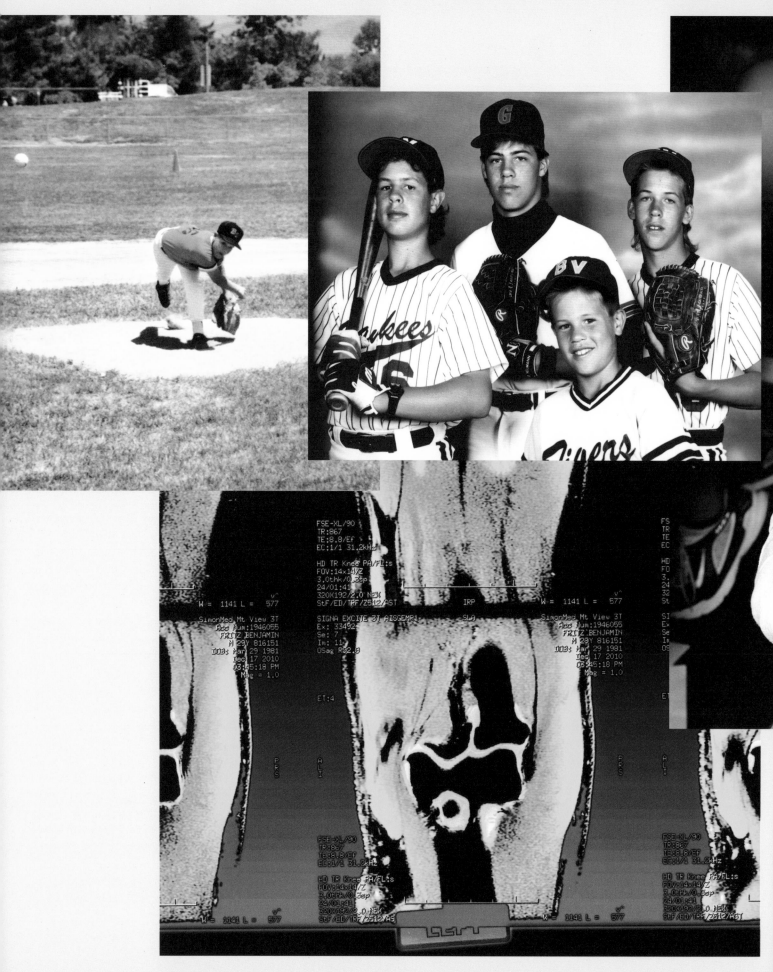

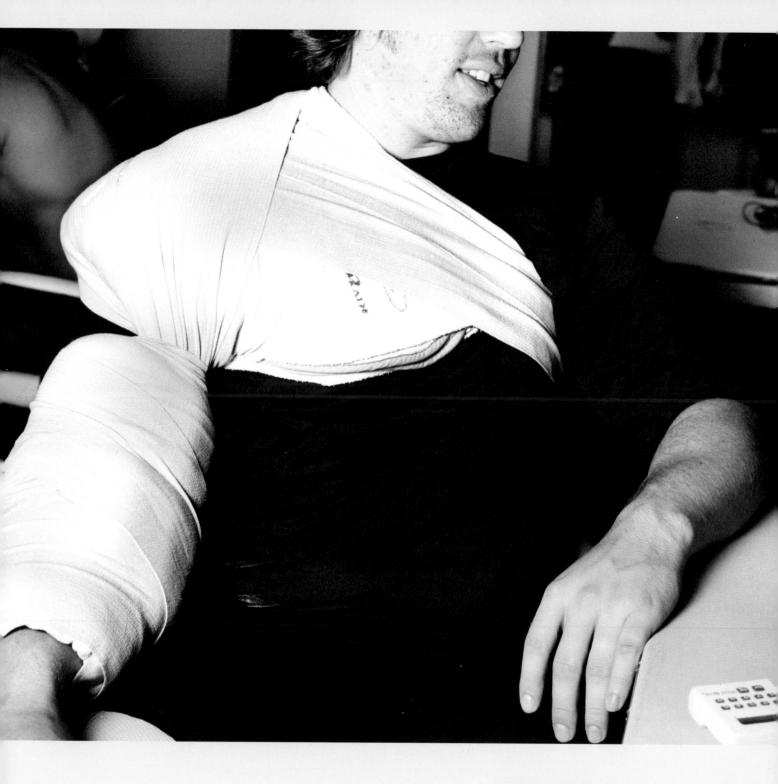

Position: Pitcher
Drafted: 2002, 1st round (30th pick) by the Oakland A's
Years playing baseball: 26
Seasons in minor leagues: 7
Seasons in major leagues: 0
League earnings: Undisclosed
Current career: Minor league manager, San Diego Padres
Marital status / children: Married / 1

BEN FRITZ (b. 1981)

Even before I was drafted in the first round by the A's, there were many opportunities to play the "what if" game. It all started in college. I played hurt, by choice, on several occasions. What if I hadn't done that? My sophomore year I would catch eight innings and pitch the ninth on a few occasions. My junior year I would pitch Friday, play first Saturday, catch Sunday and the midweek game. What if I hadn't done that? Many of my outings I threw 120-plus pitches. Looking

back it sounds crazy, but maybe that's 'cause that's what everyone tells me.

Professionally there are many "what ifs" as well. I made several mechanical tweaks throughout my career. The bulk of them after my elbow blew out. I lost roughly 4 mph. Was it because of the surgery/rehab or the mechanical changes? I pitched through some arm issues that I didn't want to say anything about. I personally think everything happens for a reason and try not to play the "what if" game. I wouldn't change a thing

I did. I loved every minute of it. I absolutely wish I got the opportunity to pitch in the big leagues but "what if" this was supposed to be my path? I've had the opportunity to stay in baseball as a coach, and all these experiences have better equipped me to help these guys going through similar circumstances. ★

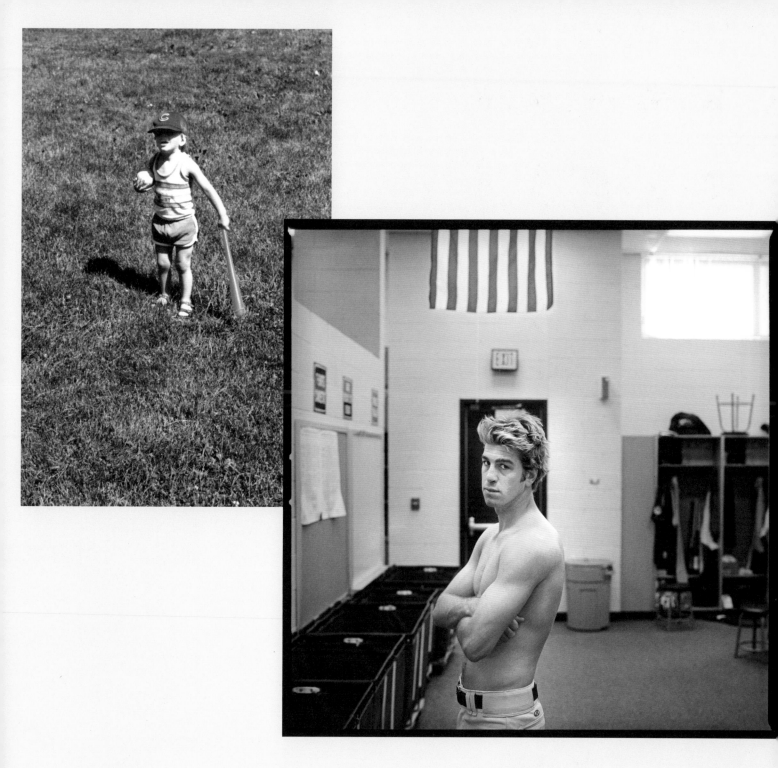

DREW DICKINSON (b. 1979)

Position: Pitcher
Drafted: 2002, 28th round (26th pick) by the Oakland A's
Years playing baseball: 25
Seasons in minor leagues: 5½
Seasons in major leagues: 0
League earnings: $40,000
Current career: Pitching coach, University of Illinois
Marital status / children: Married / 0

Since I was seven years old, all I wanted to be was a professional baseball player. Even as I got older in school and the question of "What do you want to be when you grow up?" was asked, I always replied immediately that I wanted to be a professional baseball player, not caring that people thought I was crazy. Baseball was my life, passion, and dream. I had a great high school career, which I turned into a great college career at the University of Illinois, where I was a

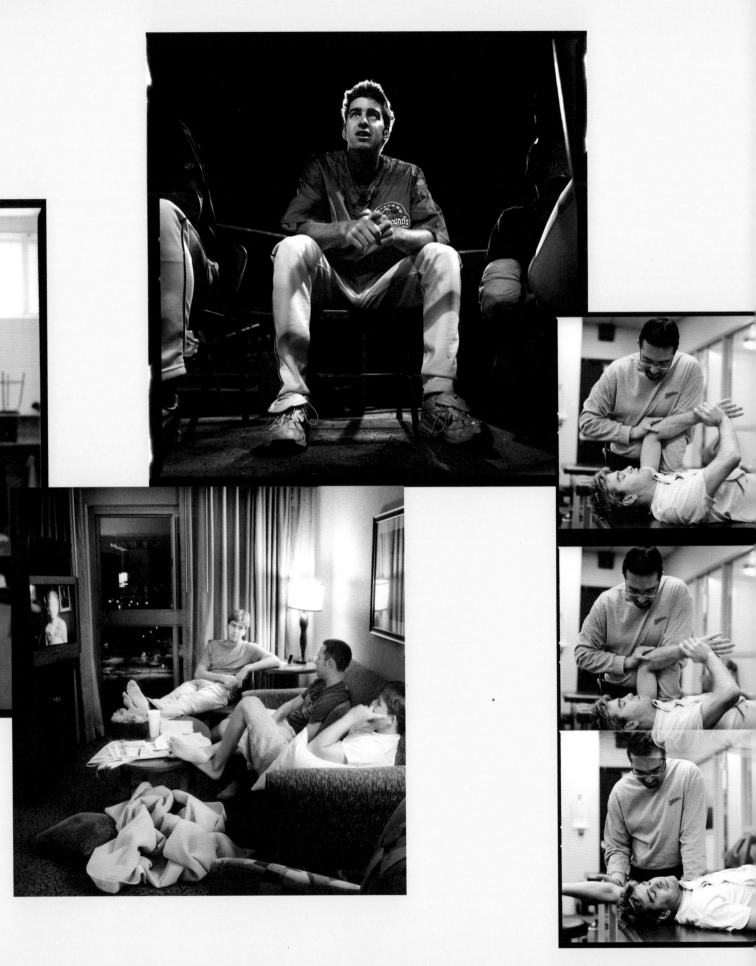

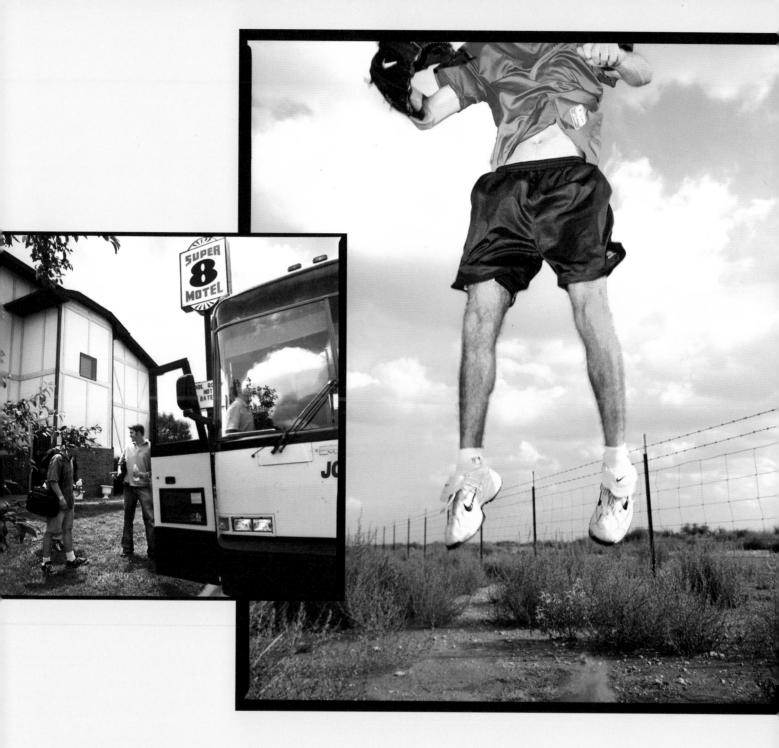

two-time All-American. In 2002, my dream came true when I was drafted by the A's in the twenty-eighth round.

I wasn't the hardest-throwing pitcher out there, but I could locate and change speeds better than most. When I was released by Oakland in 2006 I, of course, was devastated, but I had no regrets. Oakland gave me every opportunity to make it to the big leagues. But unfortunately it didn't happen. I rose quickly through the system to Double-A but seemingly hit the proverbial wall. I quite honestly just didn't throw hard enough to generate the success I needed to keep moving—and once that happens you usually end up getting released, and that's what happened to me. I went as far as my abilities would allow, and some would argue farther than anyone else would have gone with those same abilities. ★

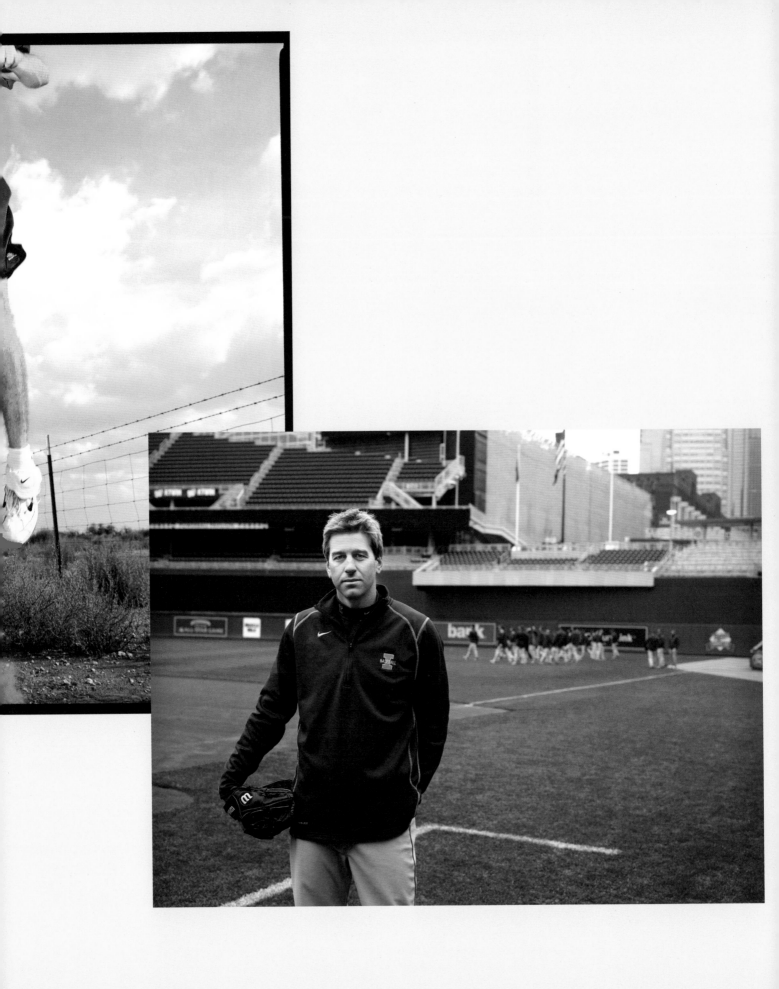

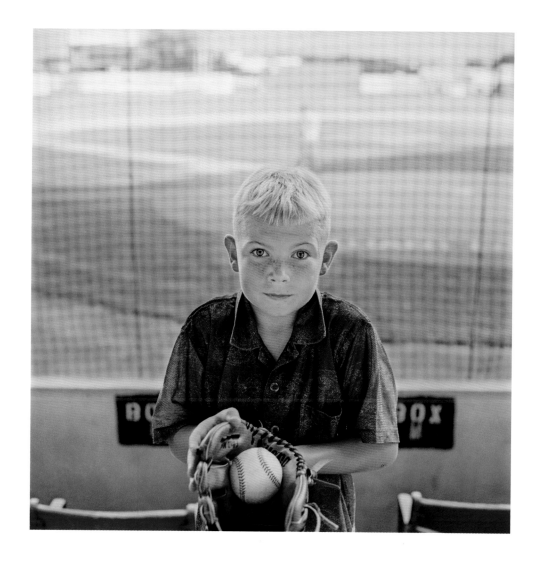

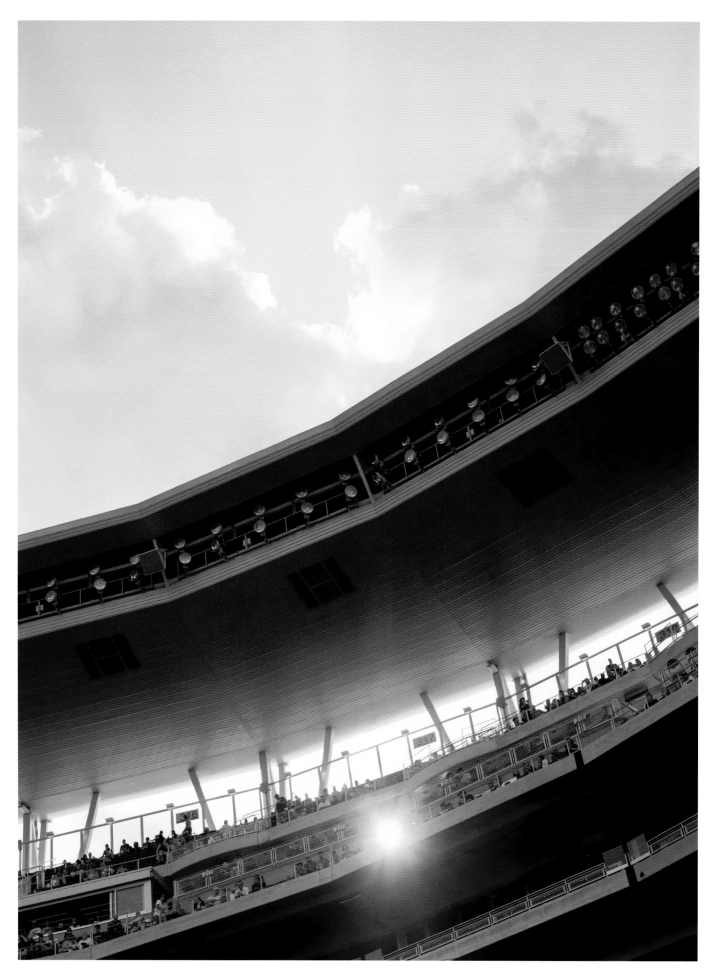

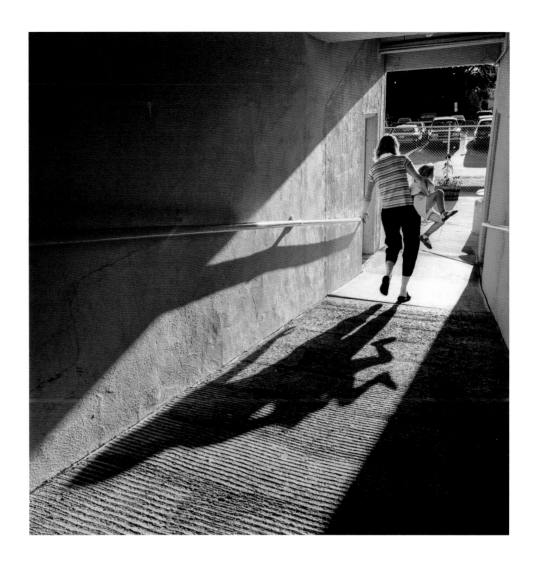

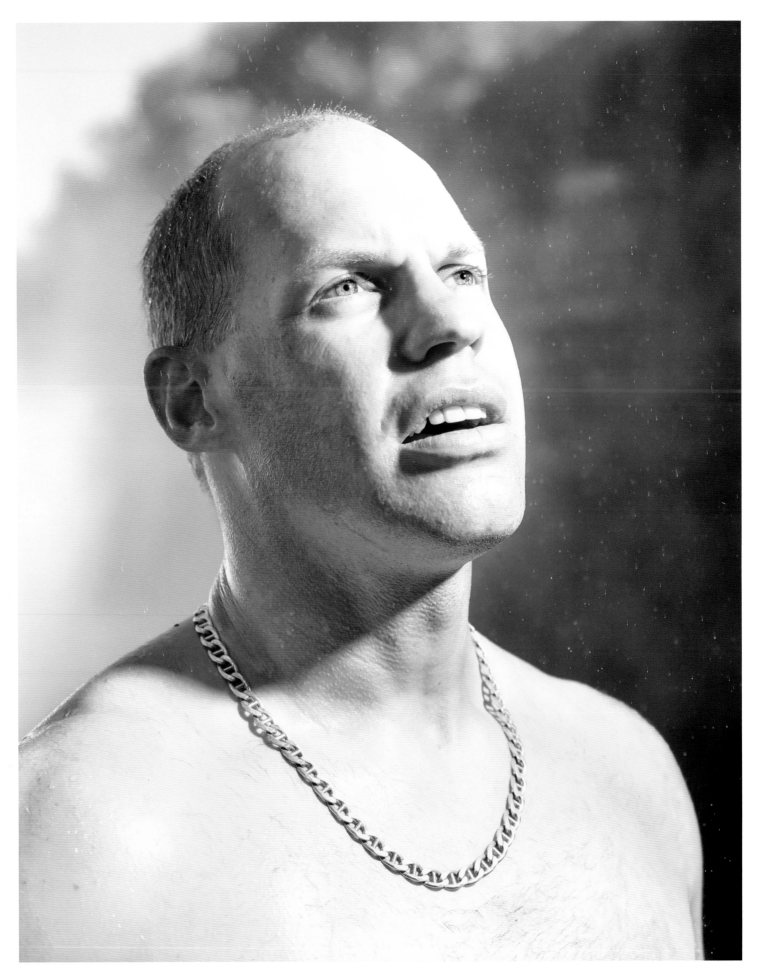

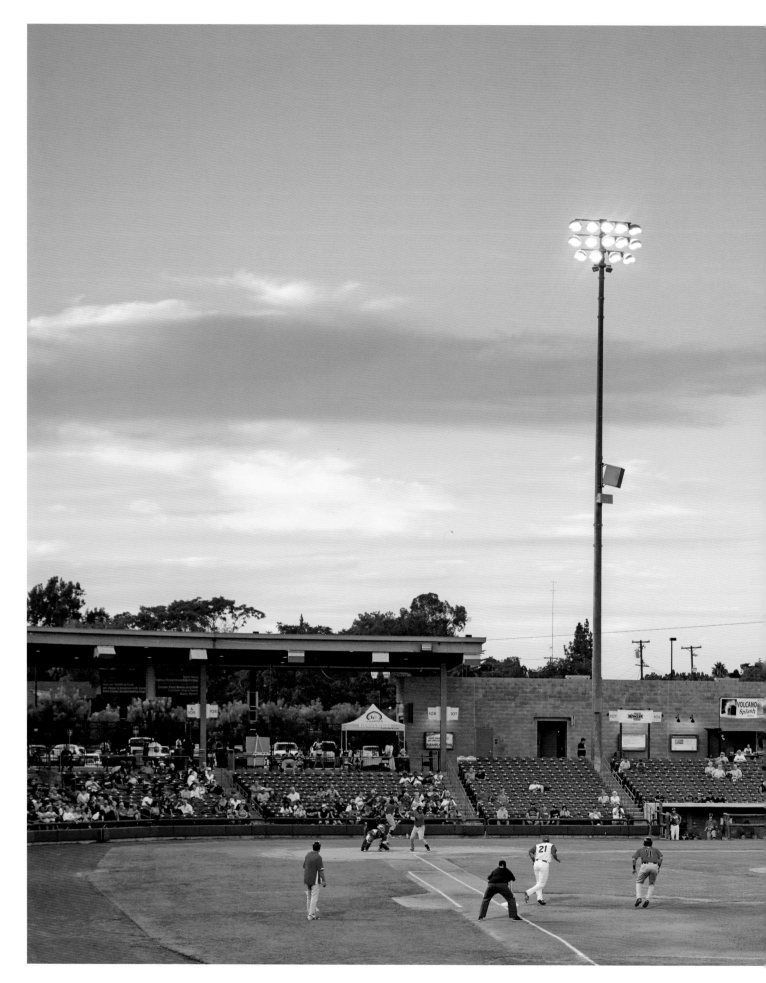

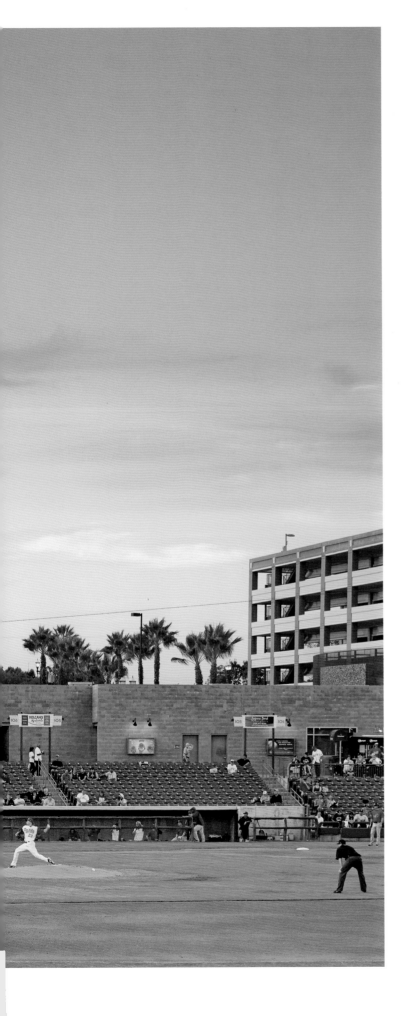

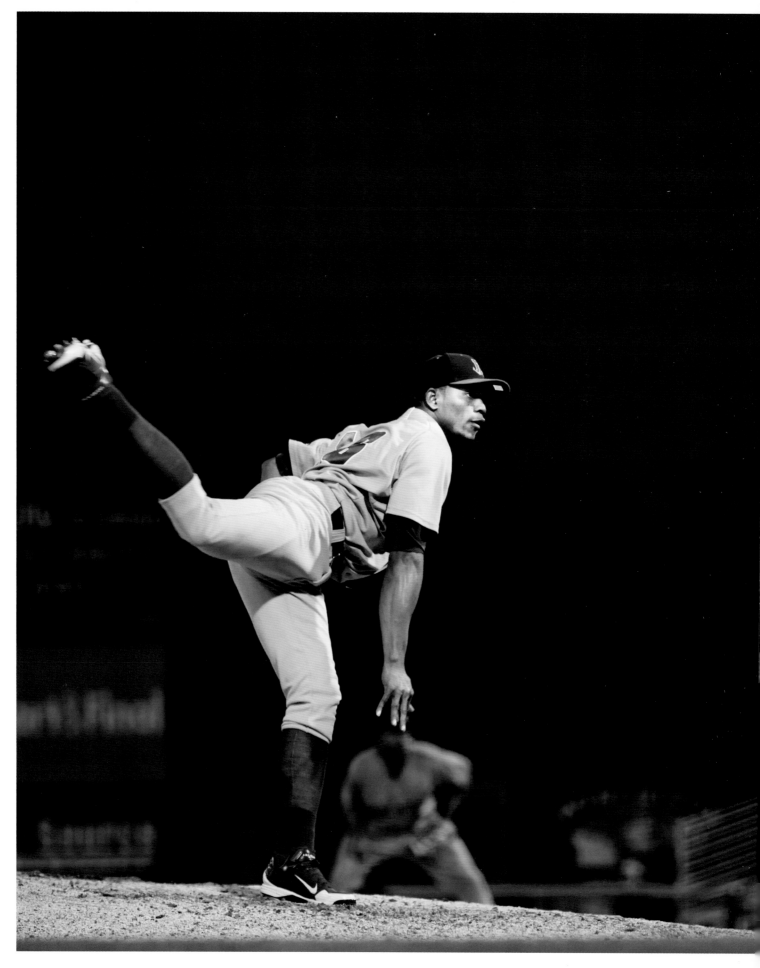

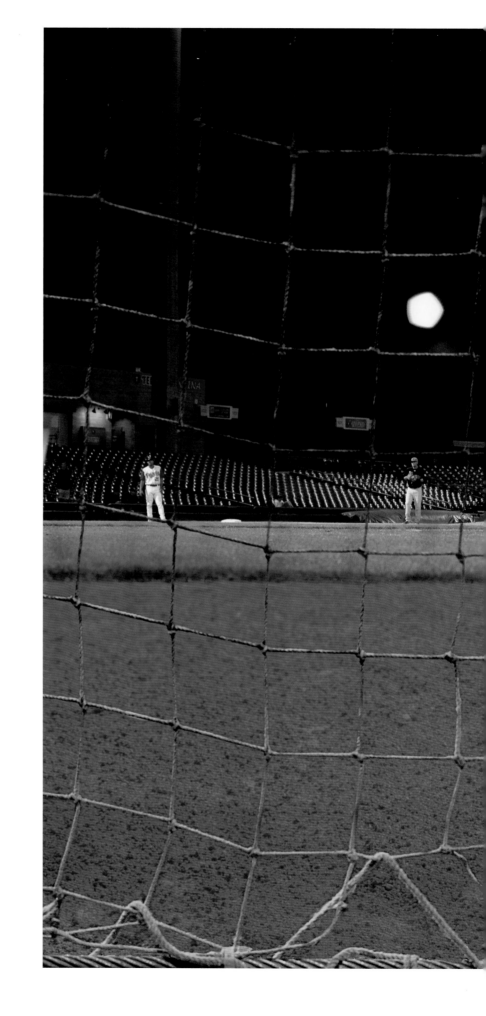

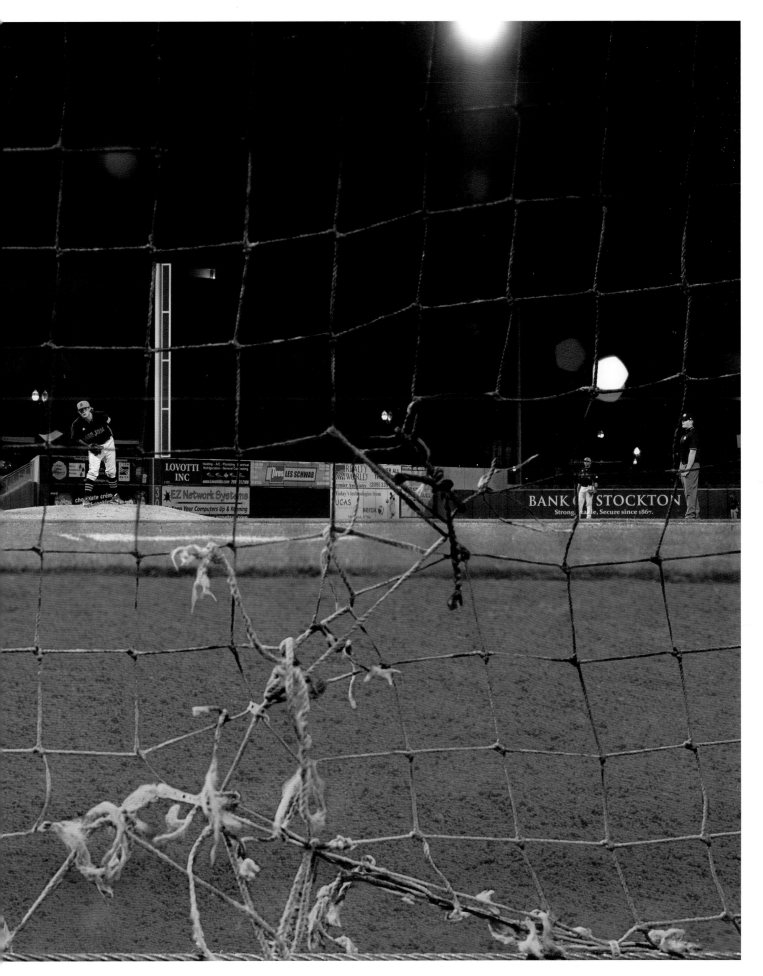

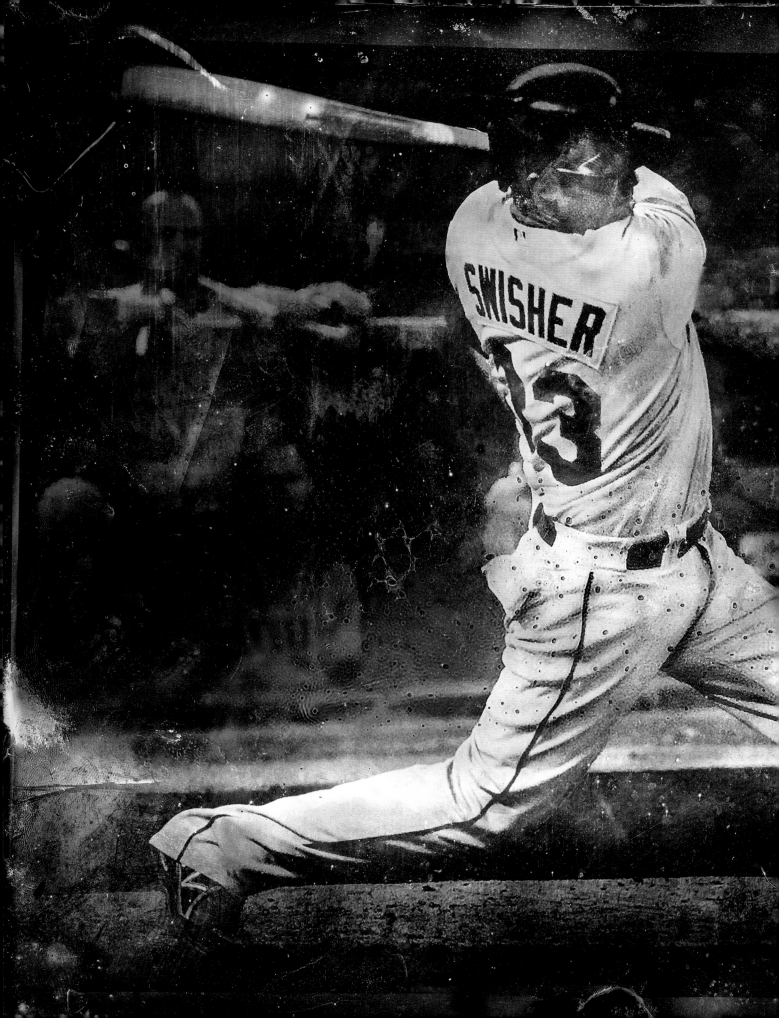

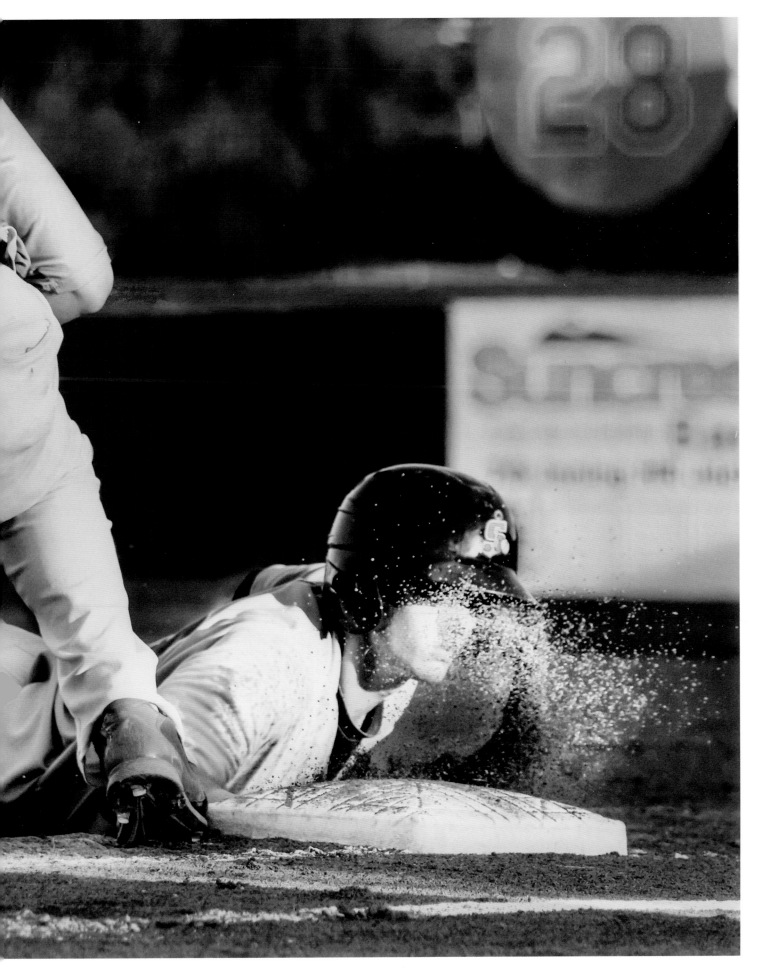

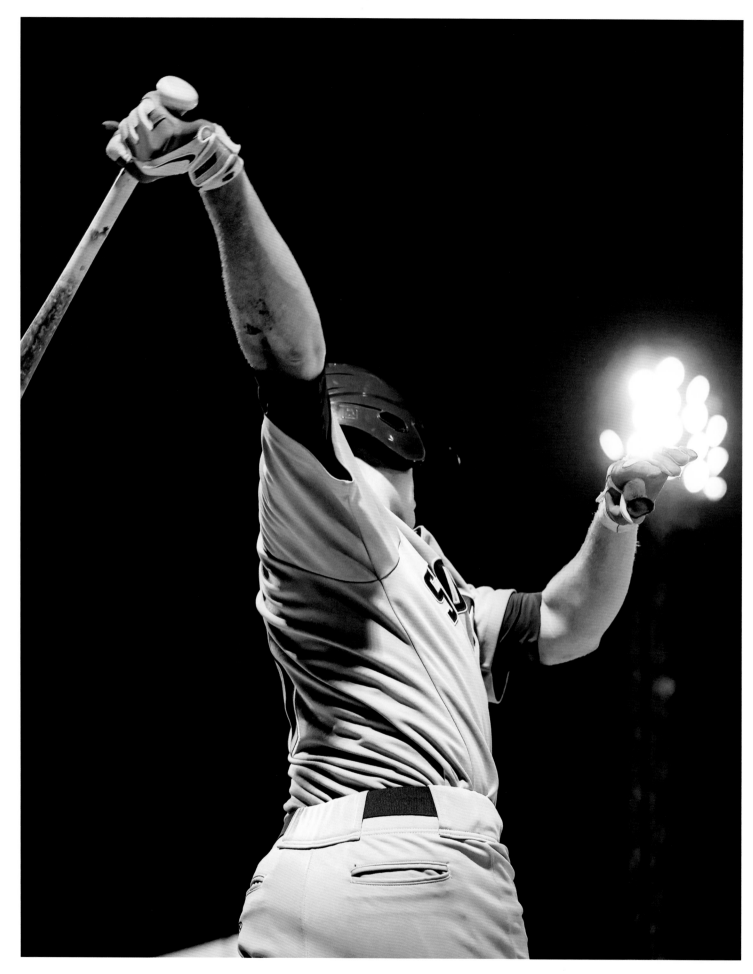

3: THE CROWD TURNED FROM BENIGN TO BLOODTHIRSTY...

Working at a sporting goods store was, in hindsight, unwise. Considering what Gee was trying to accomplish, a few months free from bunt jokes, he should have tried harder to find some other gig. He knew how to drive a forklift; he'd learned that his first off-season in Idaho. He could do roofing; Ramirez said he could get him on a crew. But Don's Sportsman's Warehouse in Billings, Montana—home of the Mustangs, Gee's third team—was right off the highway near his apartment. It paid well and he knew the merchandise. It made sense. But that was before the bunt. Or The Bunt.

"So we were in my uncle's place," said a voice. A young man's. It was coming from behind a wall of dartboards and free weights. "He was out of town, and has that incredible bed, right? So she said she wants it, and we're alone and naked—so close to probably the greatest moment of our lives."

"Then what?" said another voice. This voice said the words theatrically, in an urgent whisper. Gee knew where this was going.

"Gee Fillipacci shows up and bunts," the first voice said. It wasn't worth responding. He could snap either of these guys over his knee, but nothing good could come of it.

It wasn't as if the game had been a blowout. It was still competitive, 1–0 in the eighth inning. A real game. Yes, he knew the guy was working on a no-hitter. He *knew* the guy. He knew Kevin Hennessey personally. They'd played together in Lehigh Valley. They'd even roomed together for a month. They were friends. And yes, he knew what inning it was. And that Hennessey was five outs from a no-hitter.

But Gee had gotten a signal to bunt. Not just from the manager—from the third base coach, too. He was sure of it. And they didn't deny it afterward (but they didn't back him up so much, either).

At the time, Gee hadn't questioned it. The game was close and Mariano, who'd walked, had stolen second. If Gee bunted him over, they'd have a guy on third with one out. In a world where winning mattered, or was supposed to matter, it made sense. Small ball. Move the runner over, win the game. So Gee got the signal and laid down a decent bunt. He was an easy out at first, but Mariano moved over and could be brought home with a sac fly.

Even after Gee did it, it seemed right. From third, Mariano gave him that military salute thing he did. The crowd was cheering. It seemed all good. Gee walked back to the dugout and the team was clapping, nodding. McIntyre, who felt every loss like the death of a pet, said, "All right all right. We're in this."

But then someone in the stands yelled "Pussy." People laughed. Then someone booed. Then a lot of people booed. Someone else yelled "Pussy." The crowd, as if infected by an airborne virus, turned from benign to bloodthirsty.

Gee sat on the dugout bench and it started to sink in. It hadn't been right. You don't bunt when a guy is five outs from a no-no. A no-hitter would get a guy noticed. Gee looked to Hennessey on the mound and saw no visible emotion.

"Fucking loser!" an old woman yelled. It was an ugly thing to hear from someone's grandmother.

The next day, the newspaper did a thing about it. The Internet did a lot about it. They made up some new nicknames. Bunty McGee. Bunty McPussy. G-Buntfuck. Gee was on Bleacher Report and Deadspin. Then the Photoshop memes took over. Pictures of Gee standing with his bunt pose, bat horizontal, blocking the D-Day invasion. Gee blocking the moon landing, the signing of the Declaration of Independence.

And now this, teenagers in the sporting goods store. It wasn't worth it. He was making a thousand a month during the season, and $15 an hour here. The personal appearances, showing up at the mall when they opened a new vitamin shop, those could mean $100 a pop, but at the moment, no one wanted Bunty McPussy.

His phone dinged. It was Sheila. They'd been dating four months now. She was local. Her parents were cattle people, and she was a physician's assistant—she made more in a week than Gee made in two months.

"Hey," he said. He pictured her in that off-white sweater she was wearing the night before.

"Come over tonight," she said. Jesus. Her voice. It was so bright, like the tinkling of a wind chime, and yet it had a calm sexual power that seized his breath. When she called, during work, or just before a game, he was transported. He thought of her in her hospital clothes, the intoxication of her hair curtaining his face as she sat on his lap, and everything else was gone.

He walked to the front of the store and looked out to the parking lot, as if he could see her there. He'd forgotten about the teenagers, the bunt, baseball. He wanted only to fly to her.

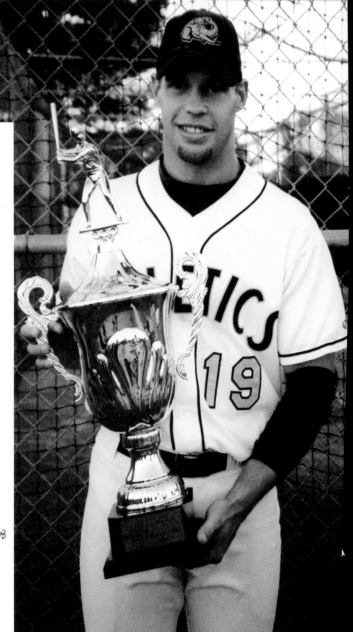

Department of Athletics

Brian Stavisky

Professional Baseball Career

2002	Vancouver Canadians	Short-Season A	
2003	Kane County Cougars	Low A	
2004	Modesto Athletics	High A	
2005	Midland Rockhounds	AA	Oakland
2006	Sacramento Rivercats	AAA	2002-2007
2006	Midland Rockhounds	AA	
2007	Sacramento Rivercats	AAA	
2007	Stockton Ports	High A	
2008	Lancaster Barnstormers	Independent	
2008	Arkansas Travelers	AA	LA Angels 2008
2009	Reading Phillies	AA	Philadelphia
2010	Reading Phillies	AA	2009-2010

BRIAN STAVISKY (b. 1980)

Positions: Designated hitter, outfielder
Drafted: 2002, 6th round (26th pick) by the Oakland A's
Years playing baseball: 27
Seasons in minor leagues: 9
Seasons in major leagues: 0
League earnings: $112,625
Current career: Sales analyst, Dresser-Rand, Horsham, PA
Marital status / children: Single / 0

As far back as I can remember, I had two dreams. The first was to go to the University of Notre Dame and the second was to play pro baseball. I had the opportunity to go right from high school to pro baseball, but my desire to play baseball at Notre Dame first was so strong I really didn't consider anything else. Our team made it to the College World Series, and I was drafted in the sixth round by the Oakland A's. I was able to finish my final academic year at Notre Dame,

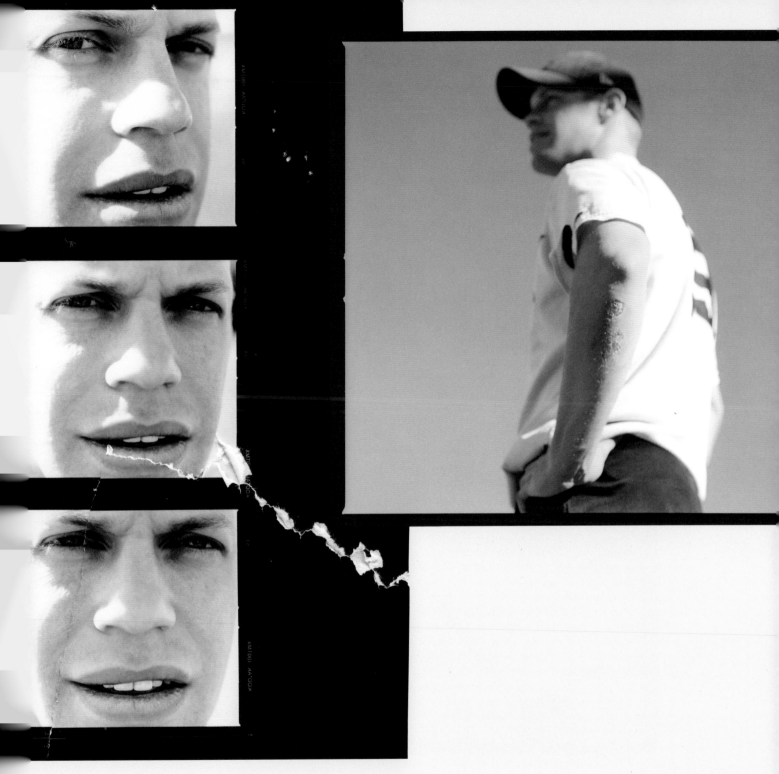

obtaining a business management degree, which was a top priority for me.

Over six seasons in the A's organization, I moved up from Short-Season Single-A to Triple-A. It was all about moving up to the next level, and ultimately trying to make it to the majors.

It was tough playing well, sometimes for entire seasons, and not getting the recognition I thought I deserved. At different times I thought, *What more do I need to do to get more credit?* However, I realize I was playing with many other

talented players, we always had good teams, and it was up to the organization to make player decisions, not me. I think the reason that I never made the majors was my defense and throwing ability. It was frustrating putting so much time into my defense but to never have it become a notable strength. However, I broke two fingers on my right hand about three weeks into the 2007 season, had to have surgery, and was only able to come back for the very end of the season. So, an injury also hurt me, not just my defense. I

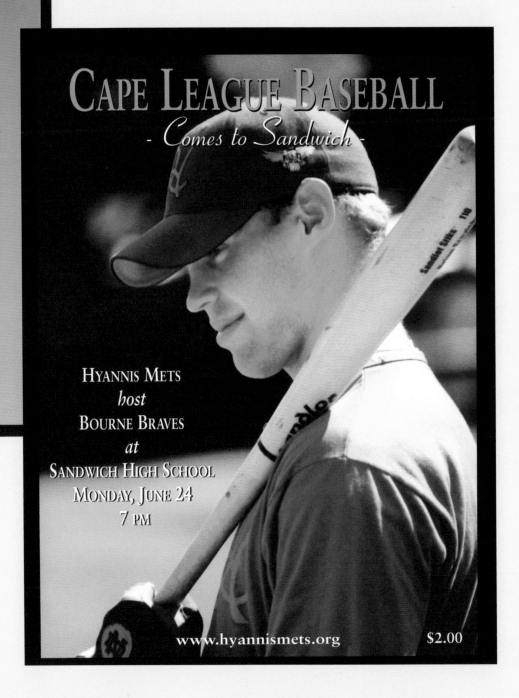

CAPE LEAGUE BASEBALL
- Comes to Sandwich -

HYANNIS METS
host
BOURNE BRAVES
at
SANDWICH HIGH SCHOOL
MONDAY, JUNE 24
7 PM

www.hyannismets.org $2.00

never played above Double-A after that.

The final three years of my pro baseball career spanned one season in Double-A with the Angels and two seasons in Double-A with the Phillies. I started to get tired of repeating the Double-A level where I had always been successful. [Over nine seasons Stavisky came to the plate 3,428 times and hit .301, with an on-base percentage of .394 and a slugging percentage of .468.] I decided to retire in the summer of 2010, moving on to pursue other opportunities with my business

management degree. When I made the decision, it was definitely tough, but I felt more relieved than regret afterward. ★

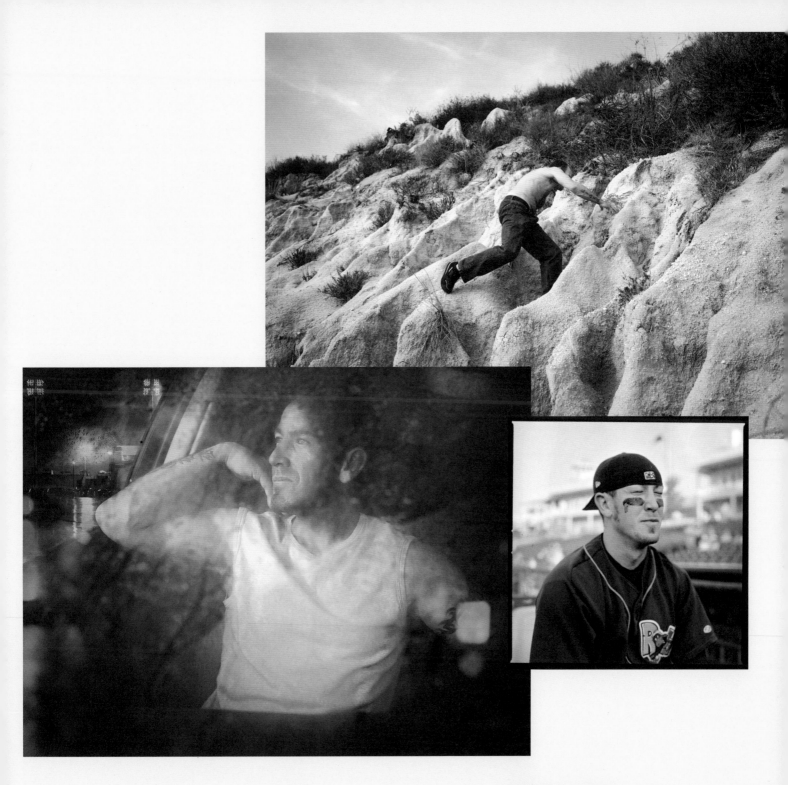

Position: Second baseman

Drafted: 2002, 5th round (26th pick) by the Oakland A's

Years playing baseball: 24

Seasons in minor leagues: 7

Seasons in major leagues: 1 playoff game

League earnings: $331,900

Current career: Little league travel ball coach, Beaumont, TX

Marital status / children: Divorced / 3

Career highlight: Only player this century to make their Major League debut in playoff game

MARK KIGER (b. 1980)

Most people think I'm an arrogant prick and hard to like. I'm a bit more cocky and have a bit more swagger than most. But when Marco Scutaro flipped me the ball during Game Three of the 2006 American League Division Series, I was so happy that I wanted to flip the ball over my head and bounce it off the pitching rubber! I am the only player since Bug Holliday in 1885 to make my major league debut in a postseason game.

I played for the Mets and the Mariners

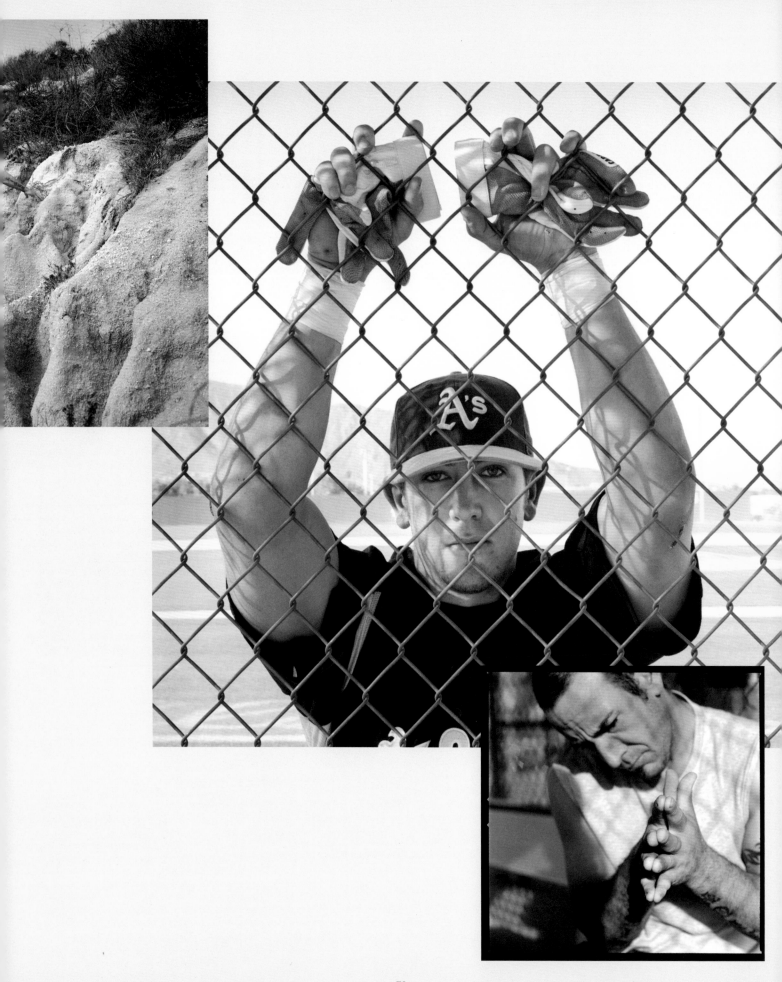

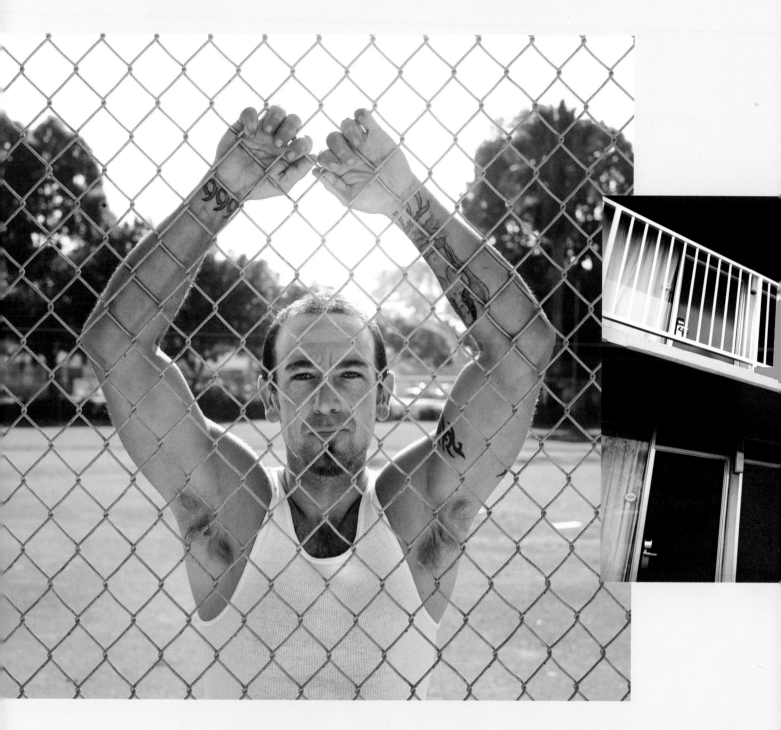

organizations after six years in the minors for the A's. In 2008, I twisted my middle finger around in a complete circle in the middle of a swing and now, the fingers on my two hands don't align. Because it was displaced, the finger needed three pins put in it to keep it straight and the baseball doctors never gave them to me so my finger will forever be crooked and arthritic.

The period of 2010 to 2015 was a nightmare. Everything that could go wrong did and at the end of the day you find out that most people around you don't really care. Four people close to me—including my mother and father—died. I went and read the Bible for three months in my car. Nobody took a chance on me but myself. I fought my way back from homelessness, the depths of depression, and self-medicating the pain of my divorce and the pain of not playing baseball anymore to the pinnacle of where I'm at now, and my bright future as a professional baseball coach. ★

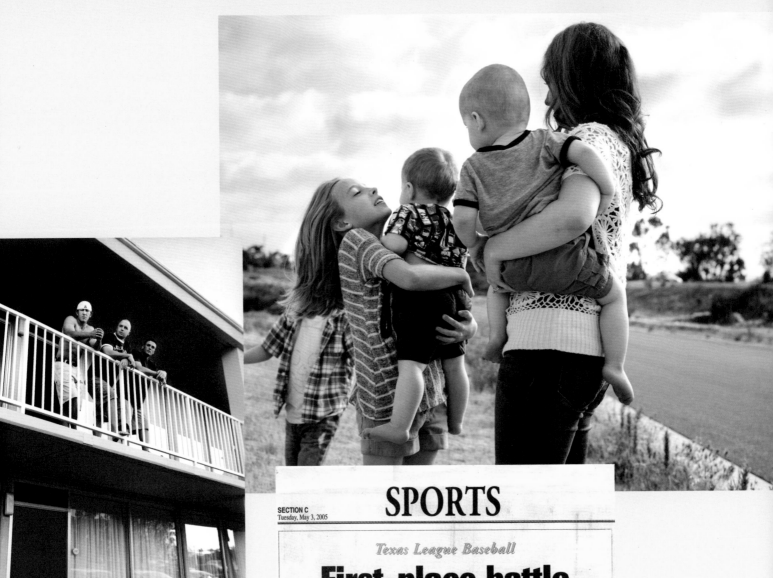

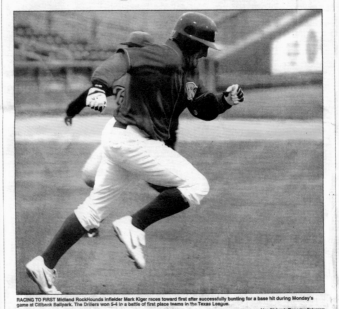

SPORTS

Texas League Baseball
First-place battle

RACING TO FIRST Midland RockHounds infielder Mark Kiger races toward first after successfully bunting for a base hit during Monday's game at Citibank Ballpark. The Drillers won 5-4 in a battle of first place teams in the Texas League.

Alec Richards/Reporter-Telegram

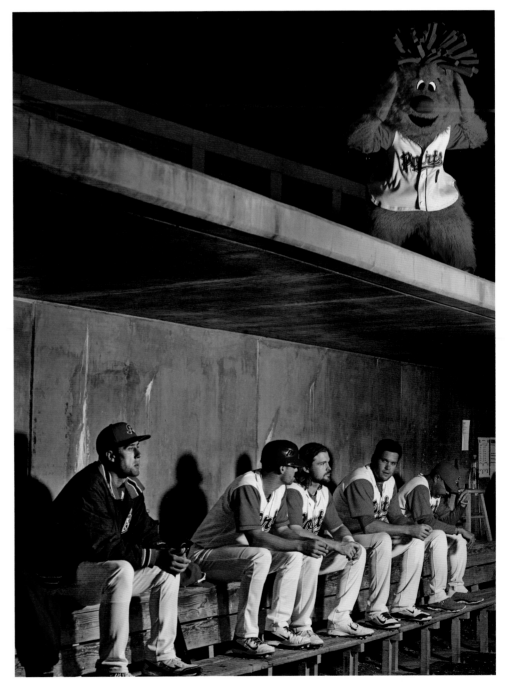

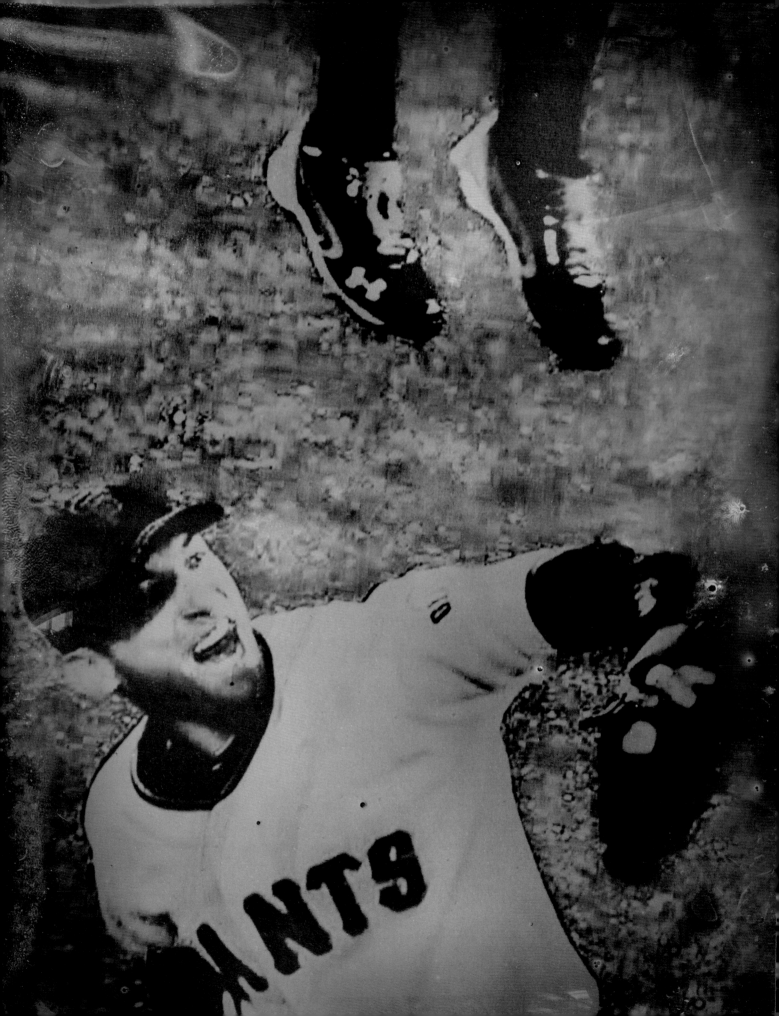

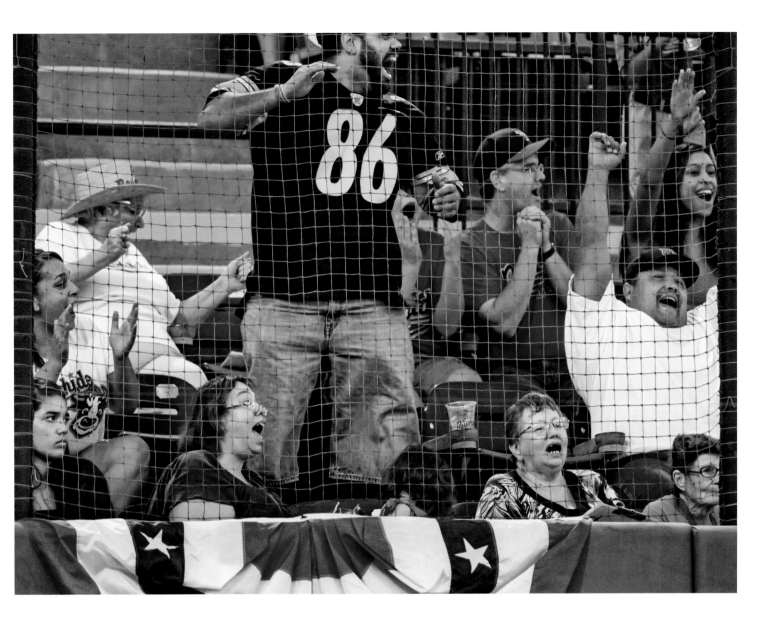

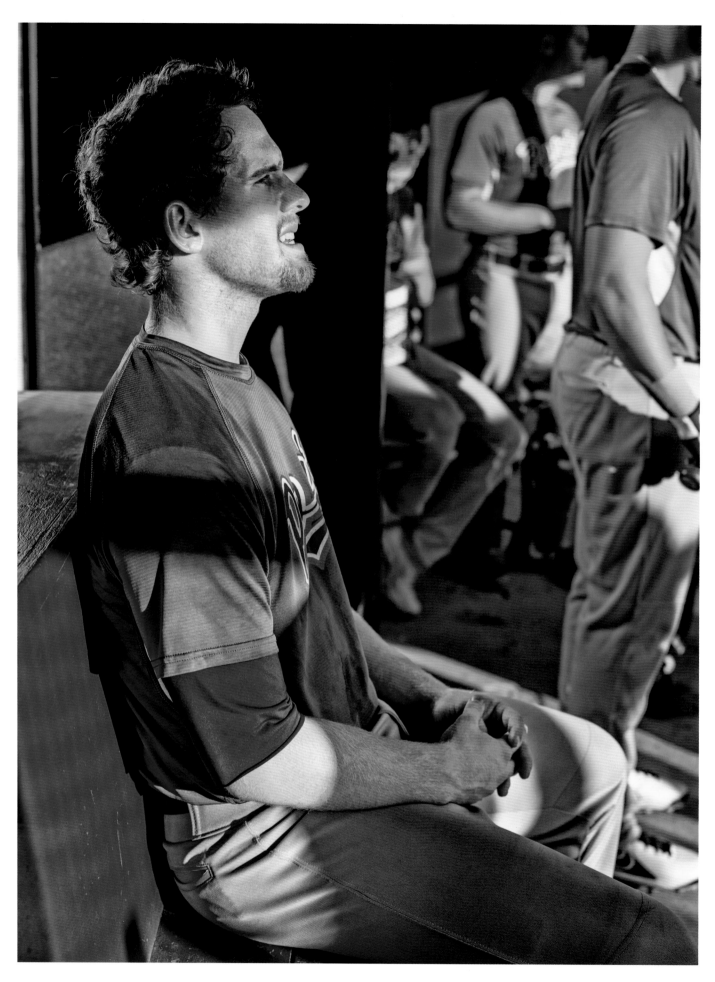

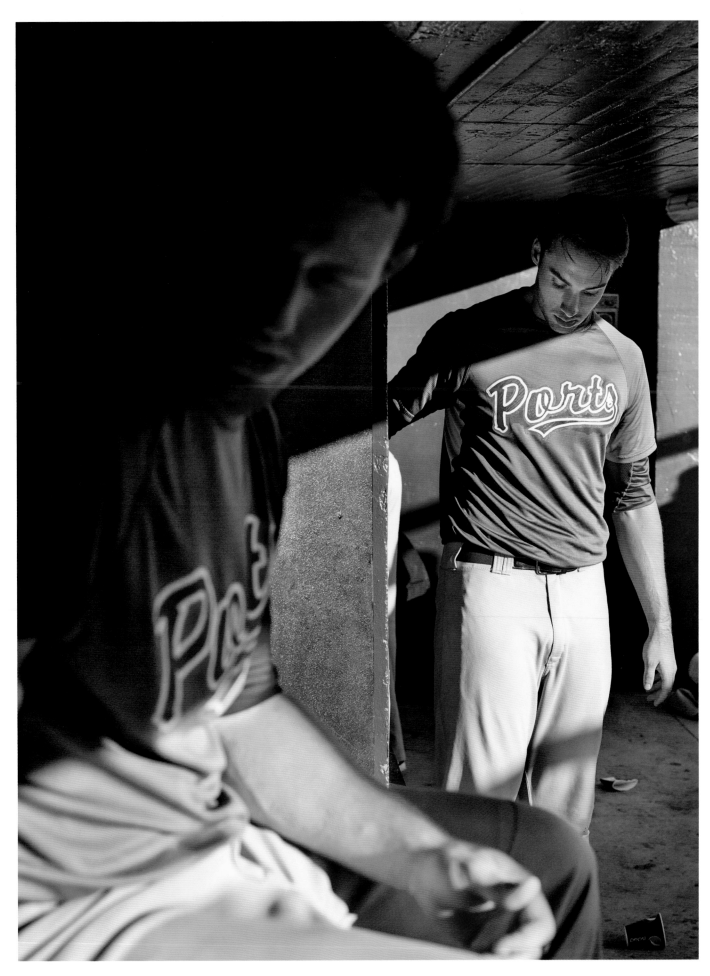

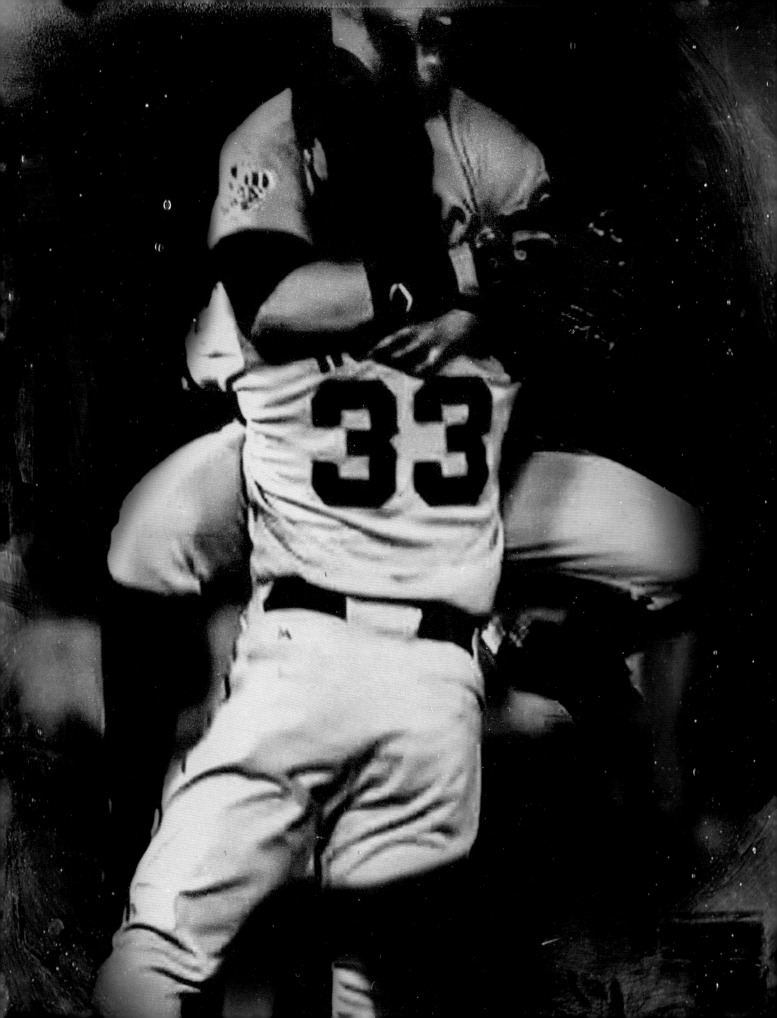

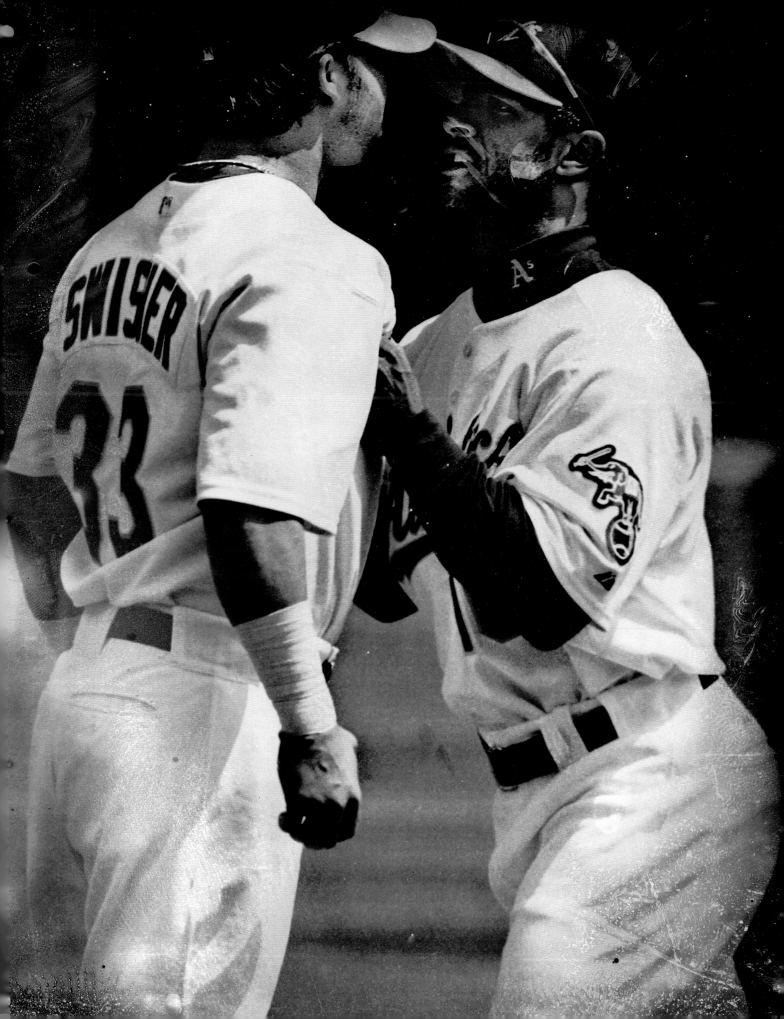

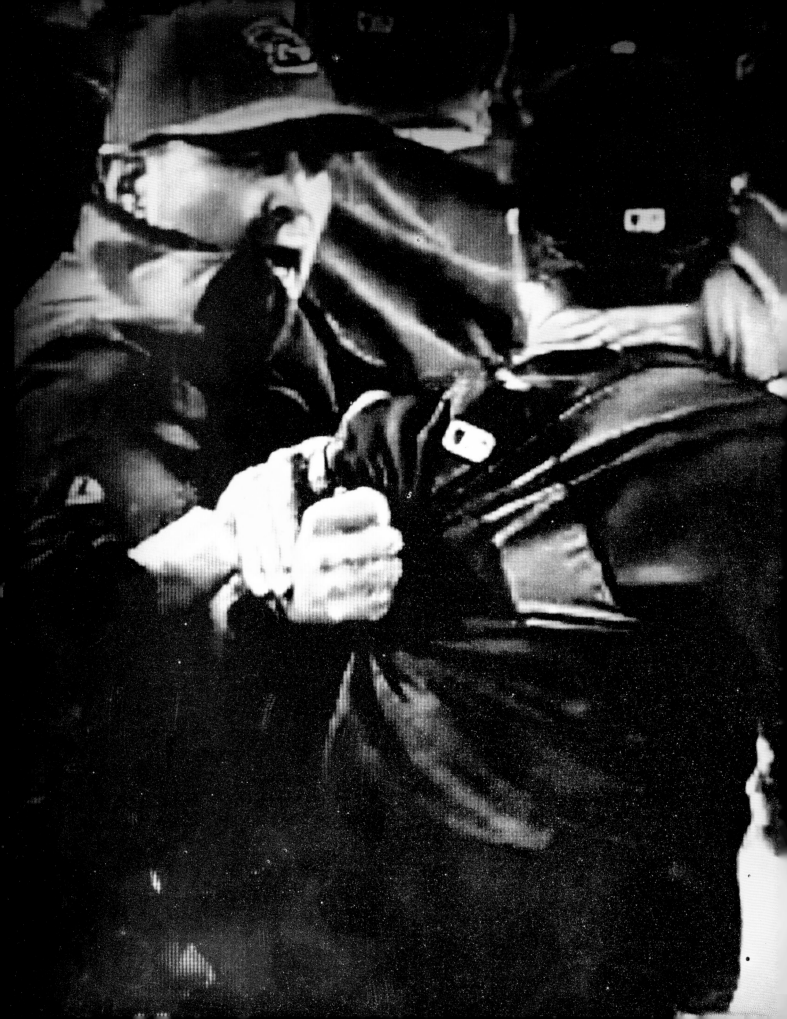

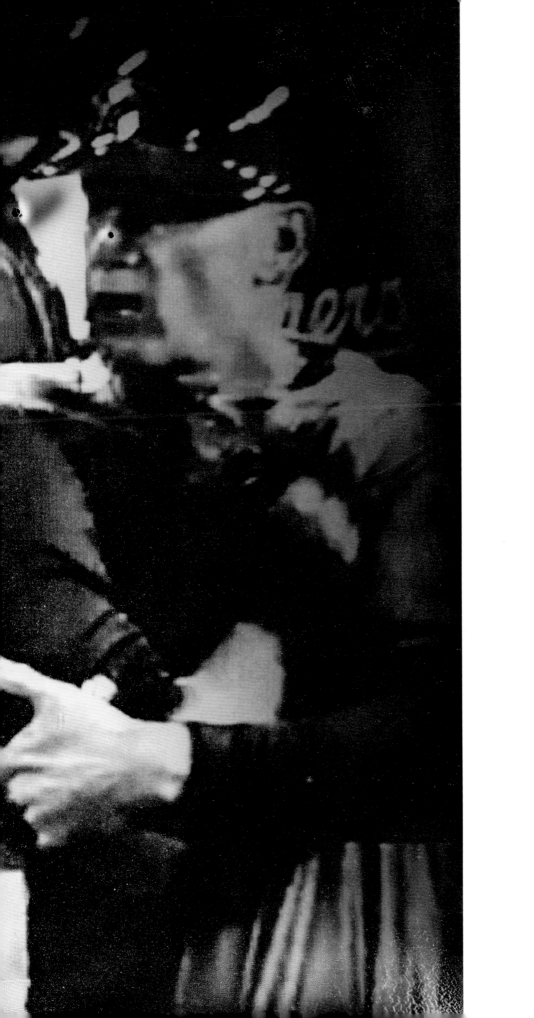

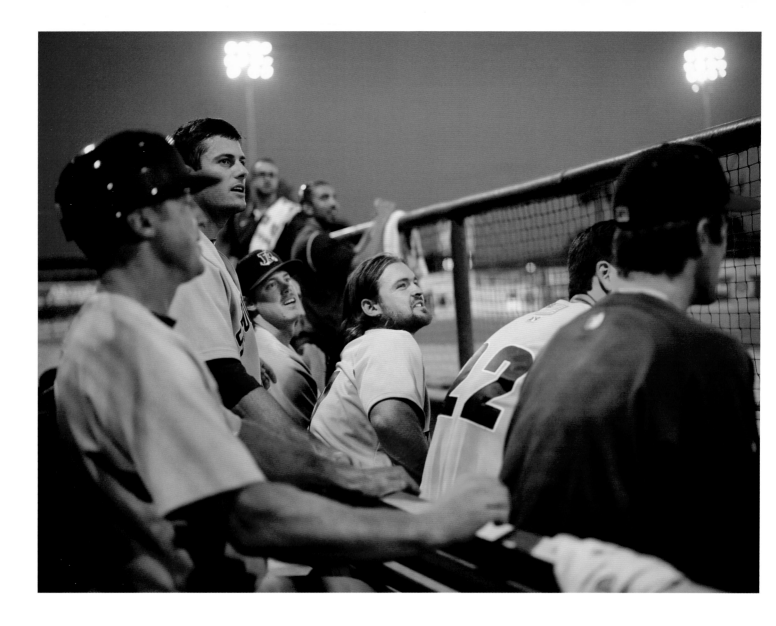

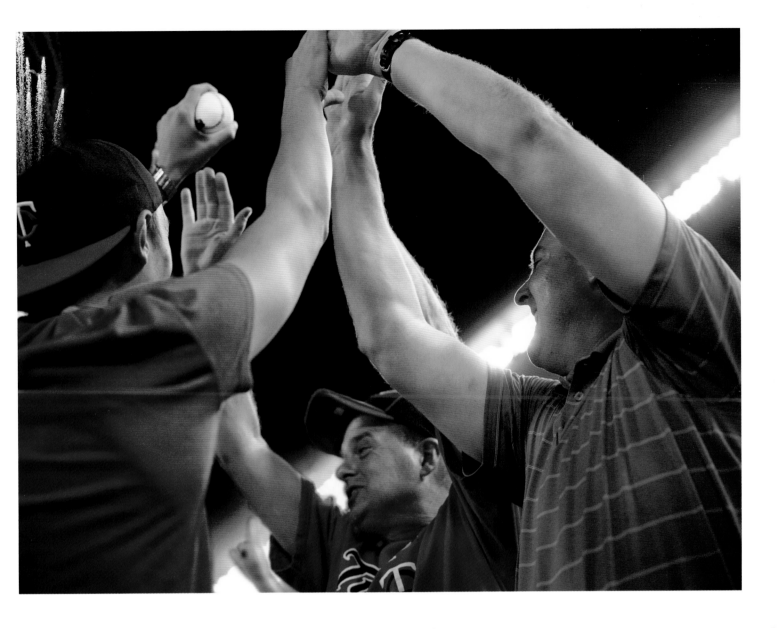

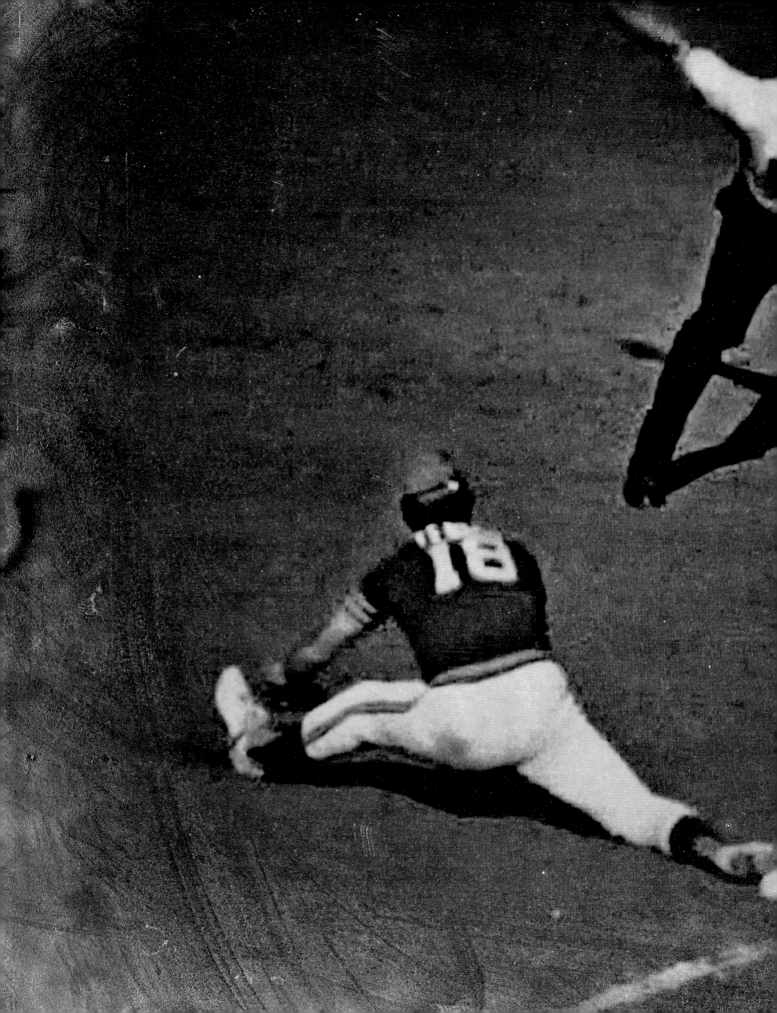

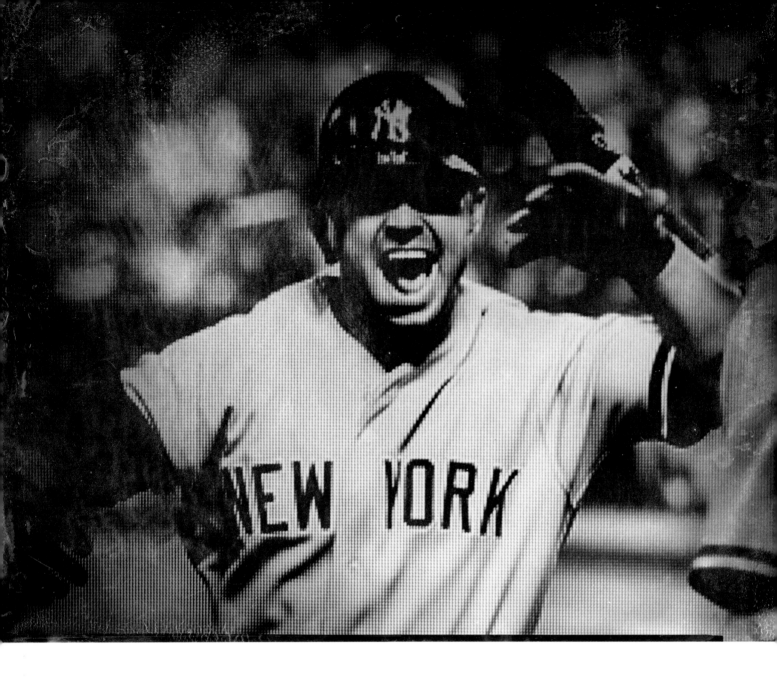

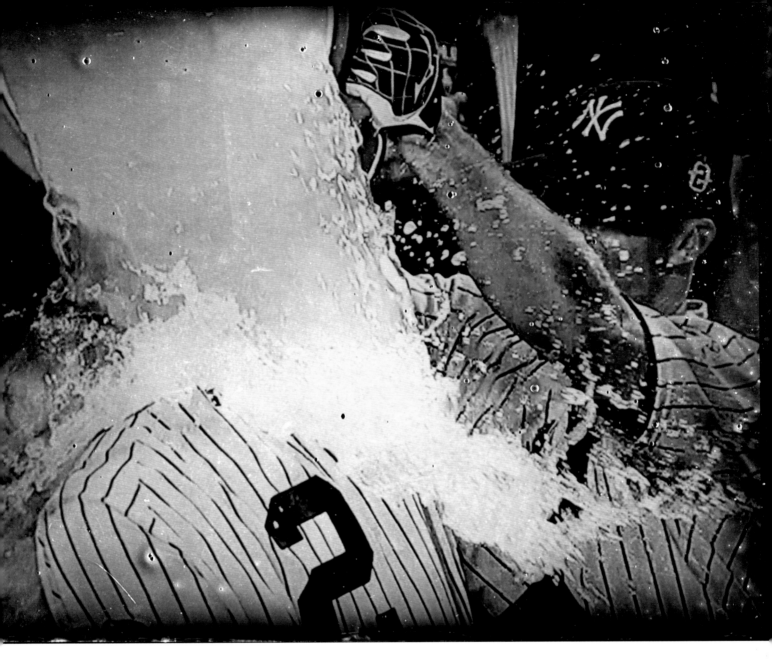

4: YOU GET TO THE SHOW, DON'T JUST WATCH.

"Heard something," Jenkins texted. Five years after he picked Gee up in that Idaho Falls bus station, and two years after he learned how to text, Jenkins was the first one to congratulate him.

Gee had gotten called up.

"I'm replacing the replacement," Gee texted back.

"And this is bad why?" Jenkins wrote.

Steve Thomason, the Dodgers' second baseman, was hurt, and the Dodgers had called up Geronimo Parada, who everyone assumed would have the starting job after Thomason retired anyway. But then a week into it, Parada got spiked during a double play and he was out, too. For a few weeks at least.

Gee was twenty-five and was packing in the dark. He was in Tulsa, playing for LA's Double-A affiliate, his fifth team in six years. Sheila had moved in. Her parents thought it was weird, her not living in the same town as her fiancé, so she took a leave of absence from the hospital and they'd rented a place in town, above a Korean barbecue.

"Okay," he said. He zipped his suitcase and made for the door. Sheila was coming the next day; her flight was $640 cheaper if they waited a day.

He left at four a.m. and returned home ten minutes later. He ran to the door.

Sheila was there with his glove.

He drove to Oklahoma City and barely made the flight. He connected through Atlanta and barely made that one, too. He needed to sleep but couldn't sleep; he spent both flights astounded that he'd actually almost left without his glove.

When he landed, he'd gotten a text from Jenkins.

"Swing at the first pitch," he wrote. "You get to the show, don't just watch."

Gee got to the stadium at three in the afternoon. A guy in one of those tight suits with the skinny pants met him in the parking lot and walked him in.

"What do you think?" the man in the skinny suit asked, sweeping his arm around a VIP reception room they were passing through.

"Big," Gee said. "Clean."

The suit laughed. BP was a blur. At some point the game started. Gee stood in the infield, trying to get used to the uniform, which seemed strangely heavy. It had his name on it, though the stitcher had had trouble fitting all the letters. "There's an *I* in your armpit," the trainer noted.

Everyone all day had been kind, but no one went too far out of their way. They were professionals, and in his way, Gee was a professional, too. He was expected to get his work done on defense, and was not expected to do much at the plate.

The first two innings the Dodgers went down 1-2-3, so at the beginning of the third, Gee was up first. He'd only taken a few swings in the on-deck when he heard his name. He was batting for the Los Angeles Dodgers.

This is fine, he thought. *This is normal. Walking to the plate for the Dodgers is just like any other walking*, he thought. *So why is it I can't feel my legs?*

It was lucky it was an early game, given Gee hit twenty points better during daylight. It was lucky that the guy pitching was on the decline, and was throwing an 88-mph fastball (the guys on either side of the rotation threw 98). But it wasn't lucky Gee hit the first pitch against the right field wall. And it wasn't lucky he stretched it into a triple. He'd been playing professional baseball for five years. He could hit an 88-mph fastball and run.

By the end of the game, his uniform smelled like the infield of Dodger Stadium. He'd gone 1–4 and made a handful of decent plays at second.

"Just happy to be here," he told the reporters afterward, the two who bothered to talk to him. The next day he got a text from McGeoghan, the one they called Gandalf. He was retired now, and ran a fly-fishing outfit in Wyoming.

"I cannot believe you fucking said that," he wrote.

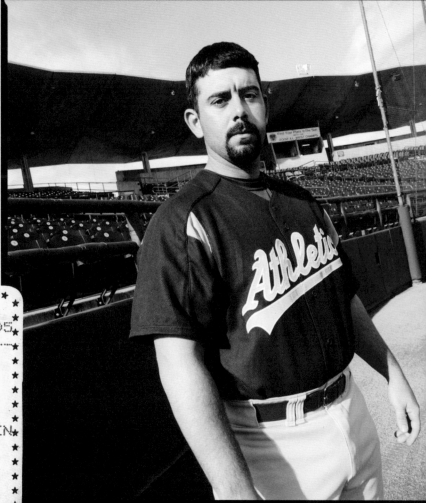

```
*****************************
*                          *
*  JEREMY BROWN    AGE:05   *
*  ----------------------   *
*  HEIGHT: 4'1"  WEIGHT: 75 LBS. *
*  POSITION: FIRST BASE     *
*  TEAM: PADRES             *
*  LEAGUE: MINOR A          *
*  SCHOOL: HAPPYDAYS KINDERGARTEN *
*  SEASON: SPRING 1985      *
*  COACH: SAMMY HOUTS       *
*  PHOTO BY: HARRIS PONDER  *
*                          *
*****************************
```

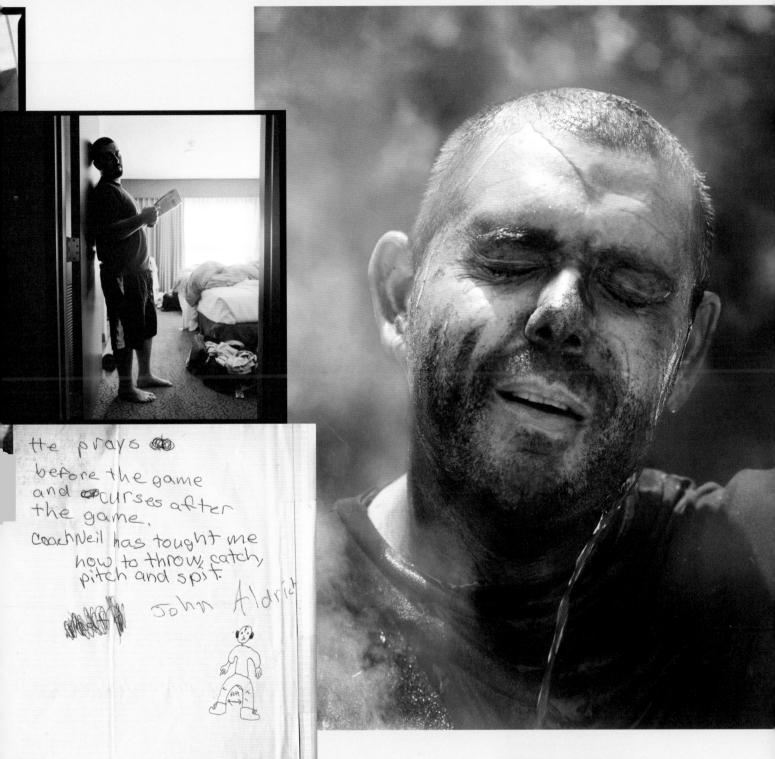

He prays ⊗⊗
before the game
and ⊗⊗ curses after
the game.
Coach Neil has tought me
how to throw, catch,
pitch and spst.

John Aldrich

JEREMY BROWN (b. 1979)

Positions: Designated hitter, pinch hitter, catcher

Drafted: 2002, 1st round (35th pick) by the Oakland A's

Years playing baseball: 23

Seasons in minor leagues: 5

Seasons in major leagues: 1 (5 games)

League earnings: $500,000

Current career: Private baseball coach, college student, Hueytown, AL

Marital status / children: Remarried / 4

Career highlight: Won the 2002 Johnny Bench Award for best collegiate catcher

Walking away from baseball was one of the toughest decisions that I have ever had to make. I had come to a point where my personal life was more important than continuing baseball. I was going through a divorce and my kids lived in Florida. I wanted to be closer to them and not traveling all the time while they were so young. I love the game and had the time of my life when I was playing. If circumstances had been different, someone would have had to rip the jersey

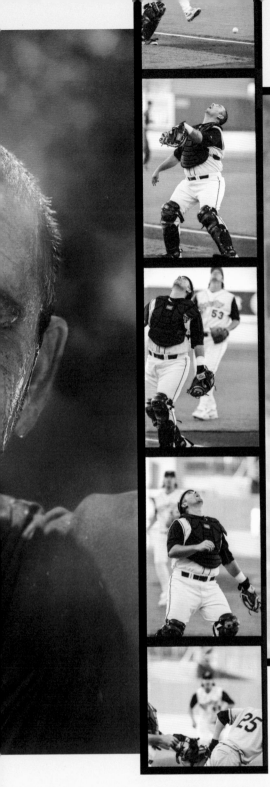

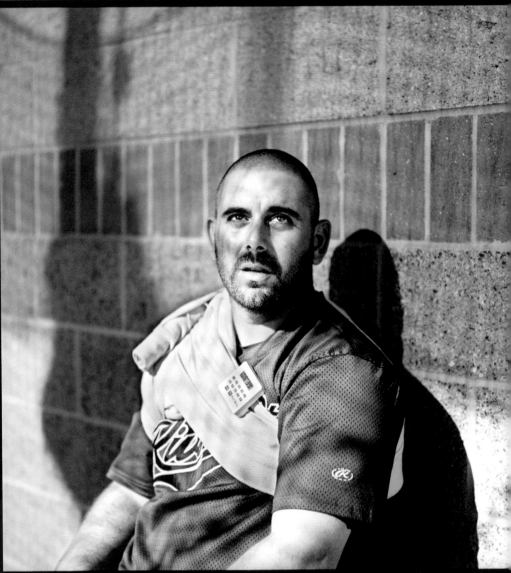

off of my back to stop me from playing.

I enjoyed the minor league lifestyle. I enjoyed what we were getting paid to do—even if it was a bit like *Groundhog Day*. You play. You come home. You work out and then play again.

I moved back near my hometown of Hueytown, Alabama, and worked as a coal miner with my dad on the night shift. But now, I've completed my college degree, and I'm about to get my teacher's certificate. I'm a regular guy from Alabama now, but I was a regular guy from Alabama when I was playing, too. I continue to work with lots of aspiring baseball players through our Dixie Youth program. One day soon, I hope to open an indoor baseball facility for the kids and coach full-time. I have a knack for it. ★

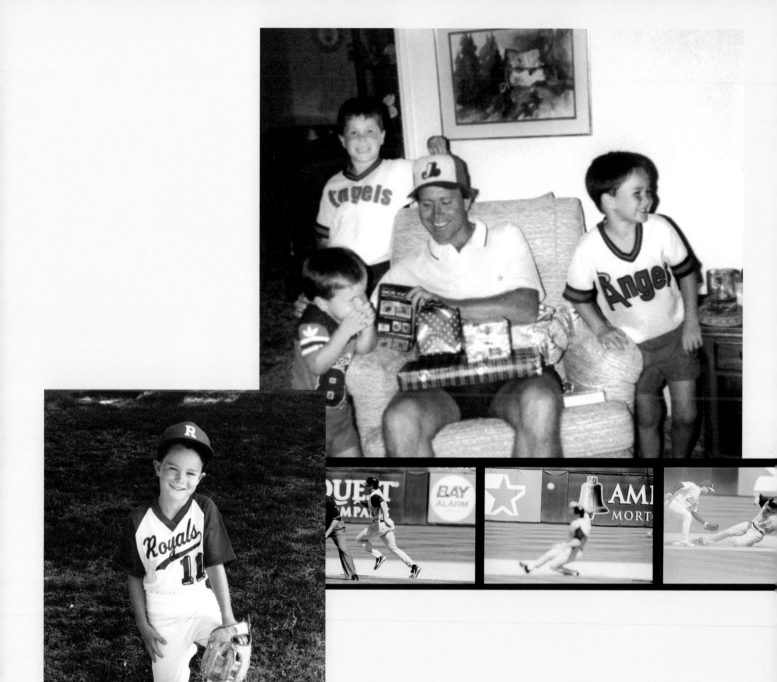

MARK TEAHEN (b. 1981)

Positions: Third baseman, right fielder, first baseman

Drafted: 2002, 1st round (39th pick) by the Oakland A's

Years playing baseball: 24

Seasons in minor leagues: 2

Seasons in major leagues: 8

League earnings: $20,989,000

Current career: Co-owner, Sorso Wine Room, Scottsdale, AZ

Marital status / children: Married / 3

Career highlight: Grand slam as a rookie off Indians' Cliff Lee in 2005

After being drafted in 2002, I completely reworked my college swing to be able to hit higher caliber pitches. Less than a year later, I was traded to the Kansas City Royals, which was the first of nine times I would change organizations.

I was with the Arizona Diamondbacks for two months, the Cincinnati Reds for one day, and the Texas Rangers for ten days. Jumping from minor league baseball in small towns on a tiny salary to playing on a national stage for big paychecks

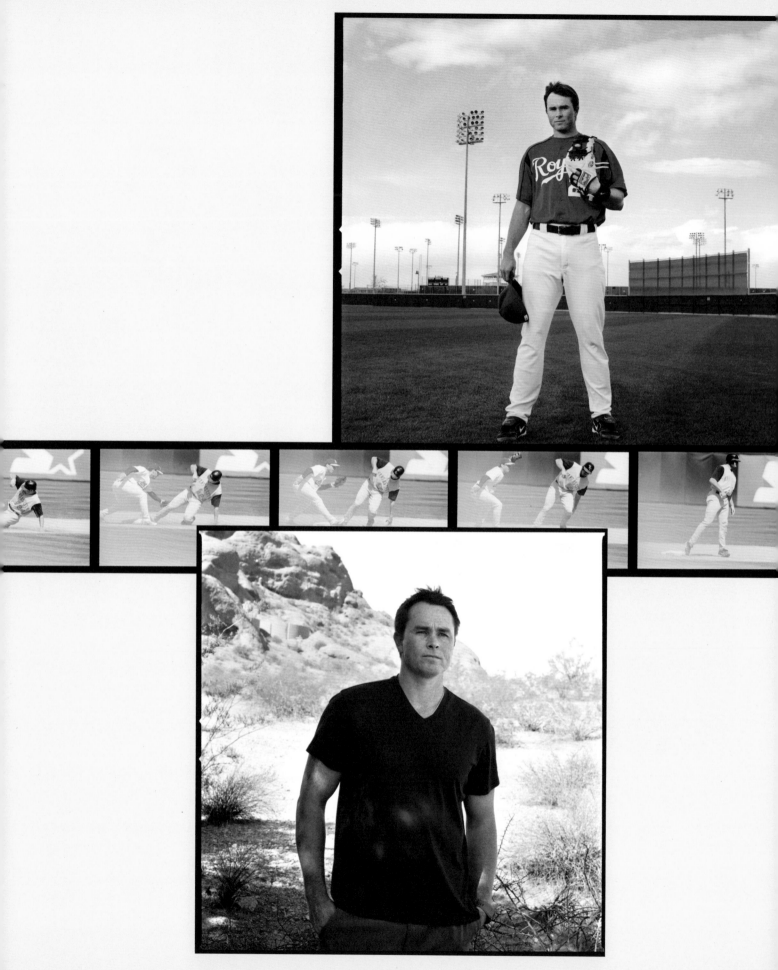

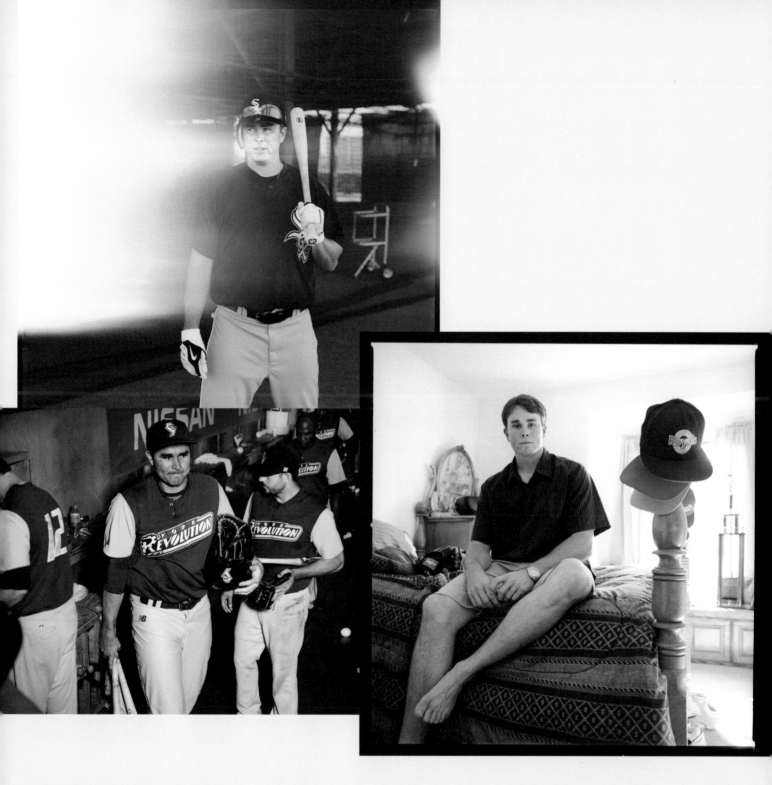

was quite the adjustment but I quickly realized tomorrow wasn't guaranteed. The game was the same, but with new teammates, new personalities, and a new organization to impress. The effort to find my niche became as challenging as being a productive player. I found myself trying to show off my skills daily to prove my worth. As a rookie, it's easy for teams to be optimistic about what kind of player you might develop into. I benefited from that optimism and was given a

lot of chances to fail, learn, and grow in the big leagues. I mostly kept my mouth shut, worked hard, and tried to absorb as much information as possible.

Shoulder surgery in September of 2006 ended my season, and the Royals told me they were going to move me to right field to promote Alex Gordon to play third base. I was initially pissed off. I had played third base my entire professional career and was coming off my best season. I didn't resent Alex because

I knew how talented he was and how much we needed help. I did resent the decision and especially didn't want to learn a new position when I was finally settling into having success at the big league level. Sometimes I wonder if my efforts to be so flexible ended up making me expendable. ★

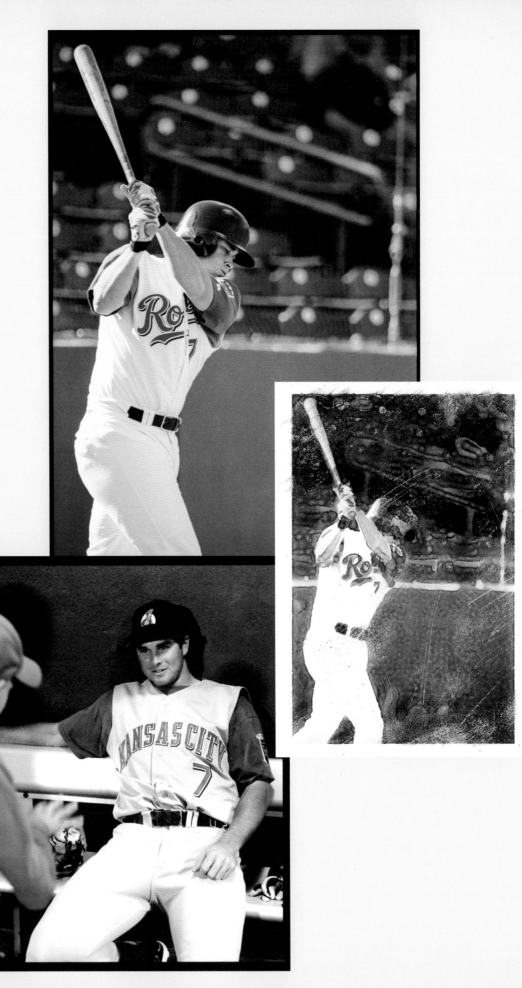

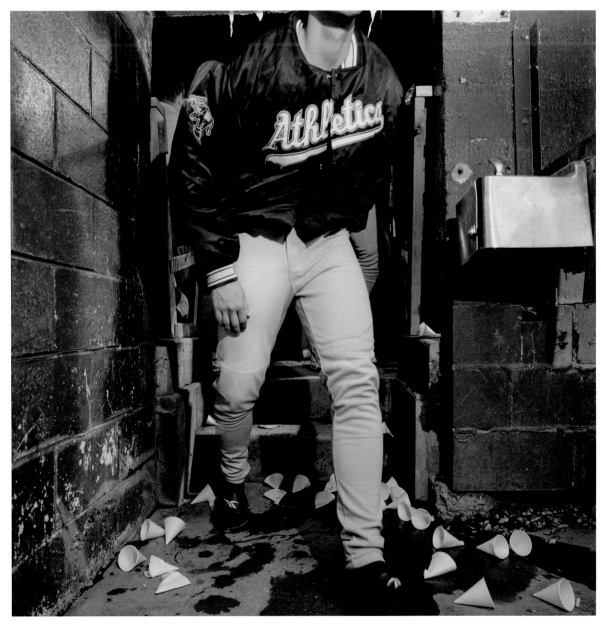

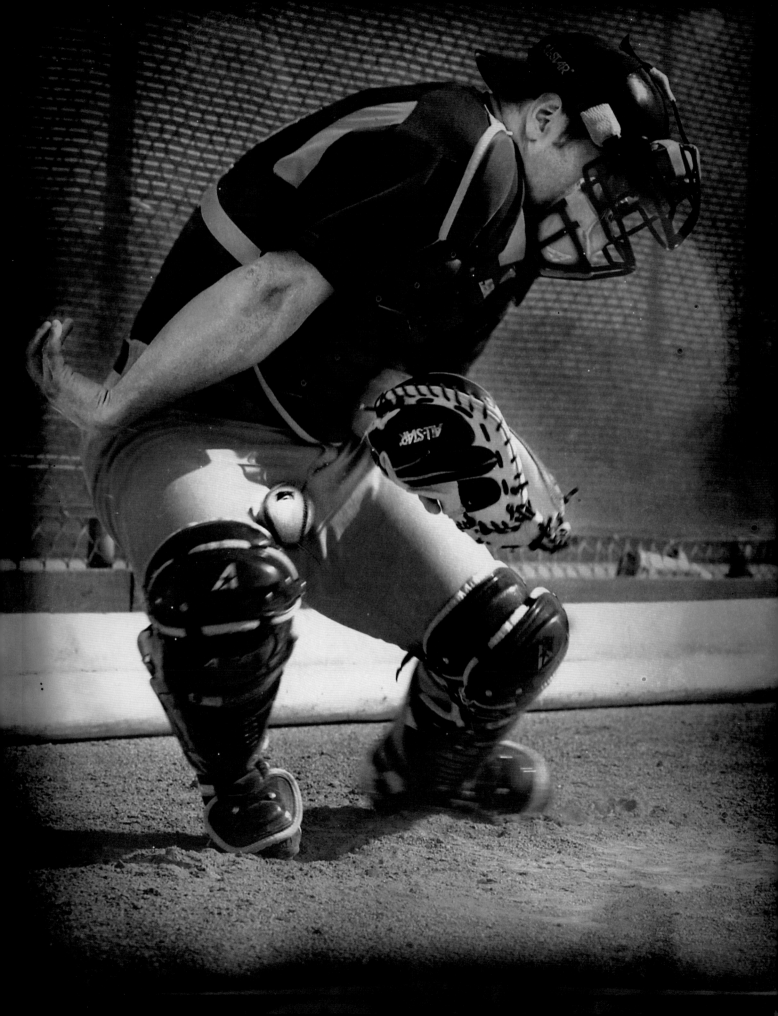

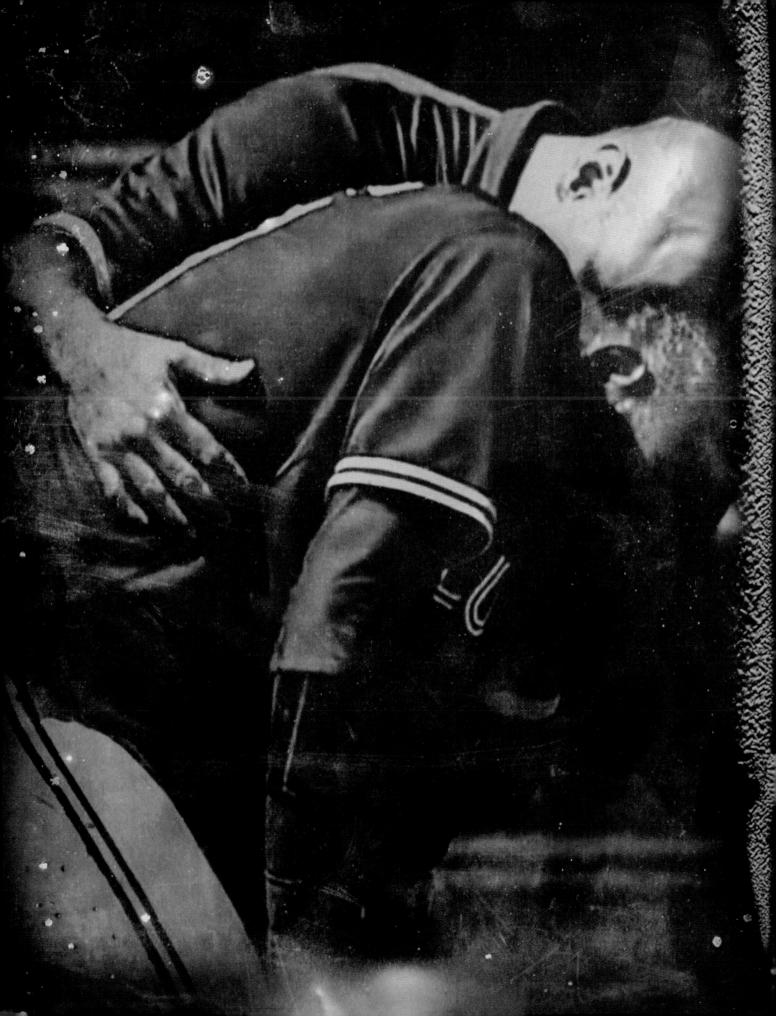

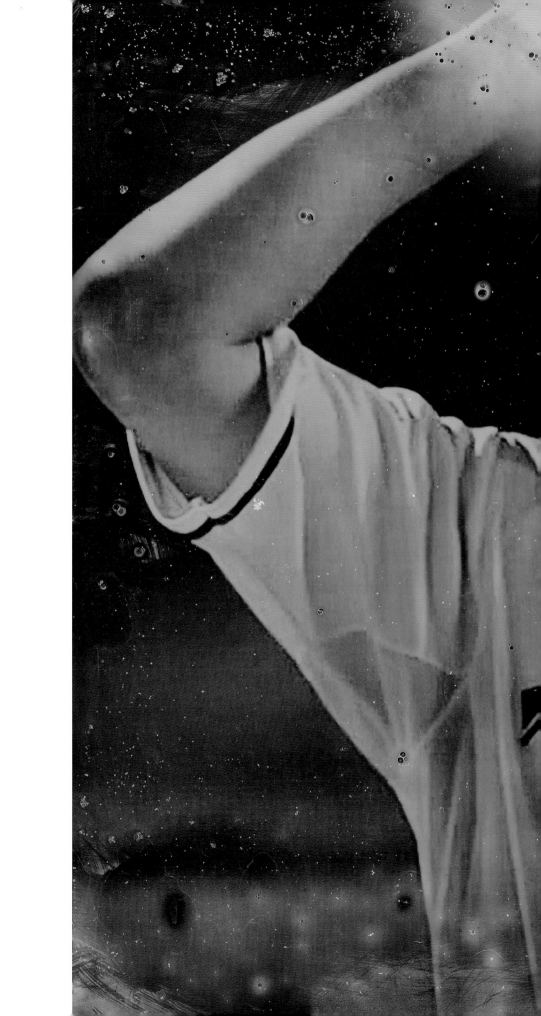

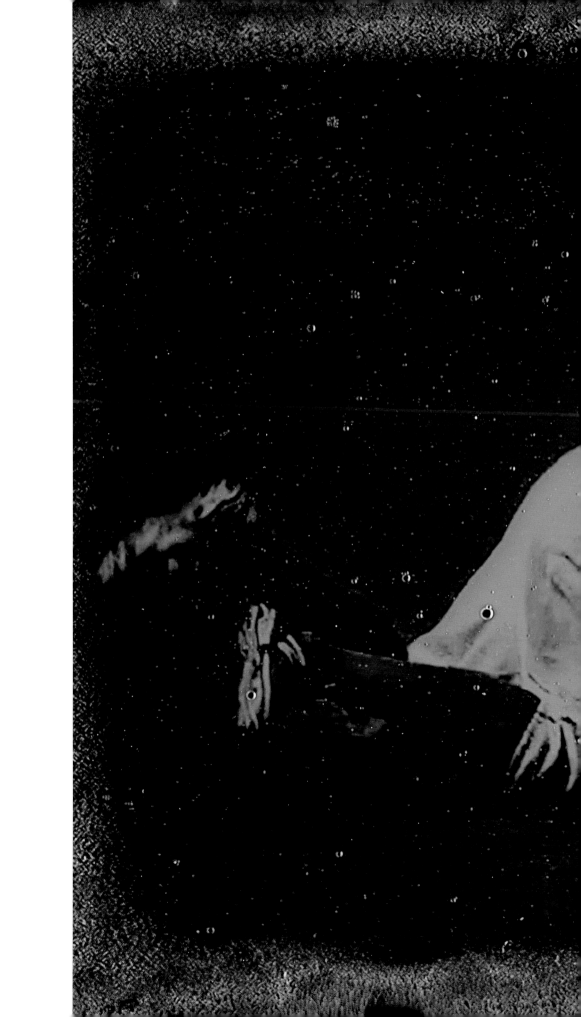

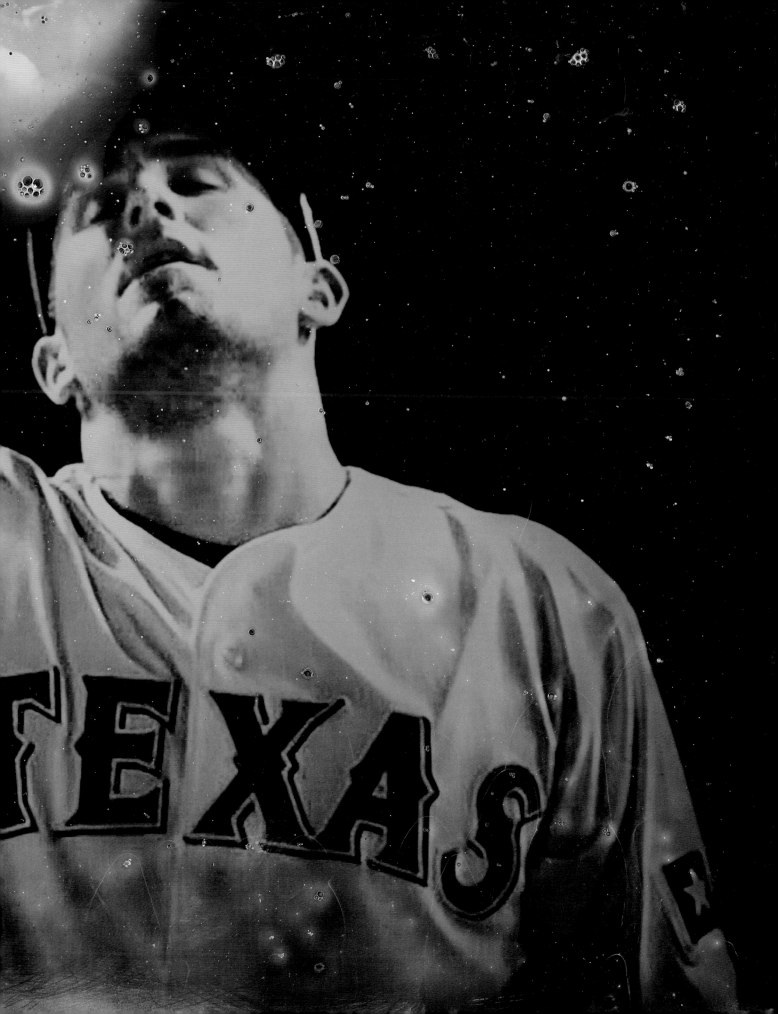

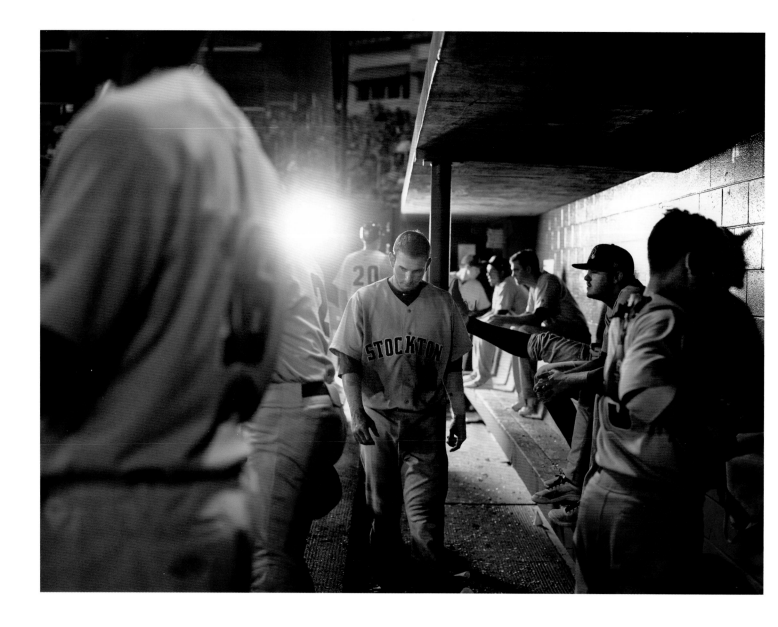

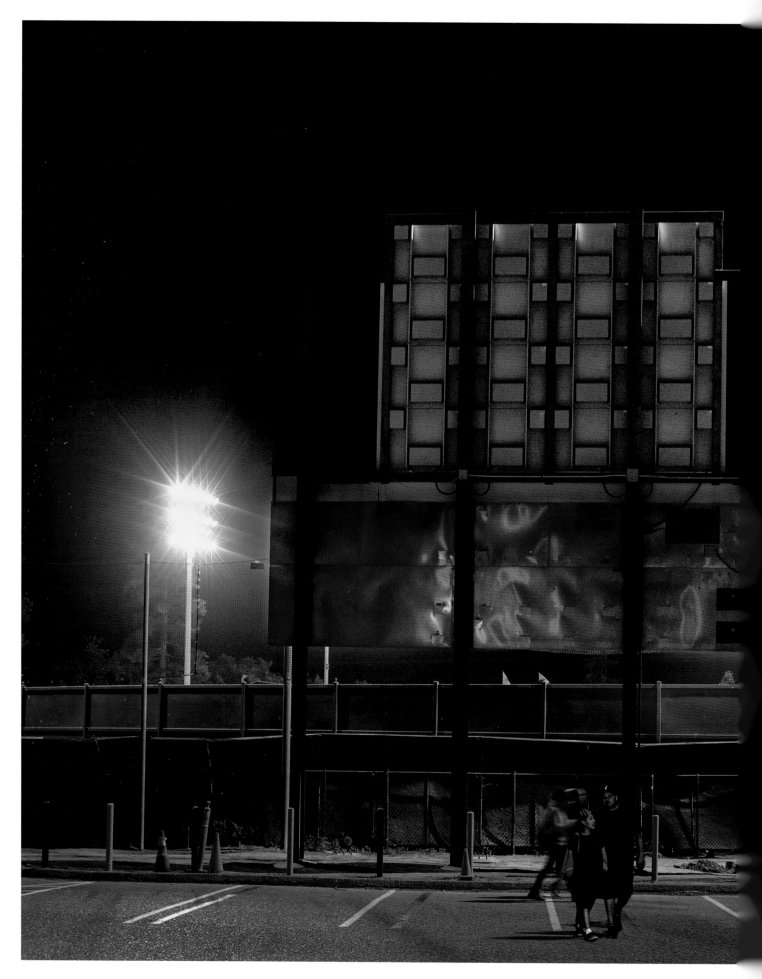

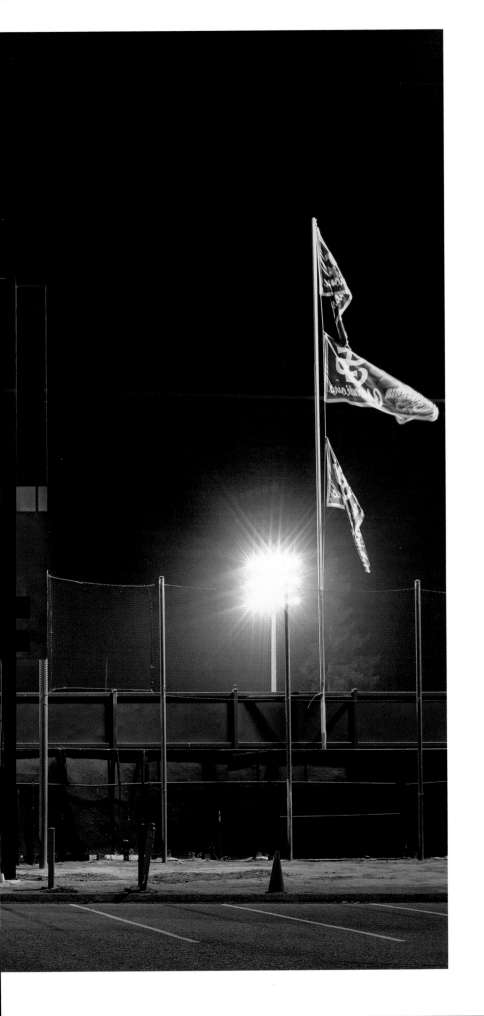

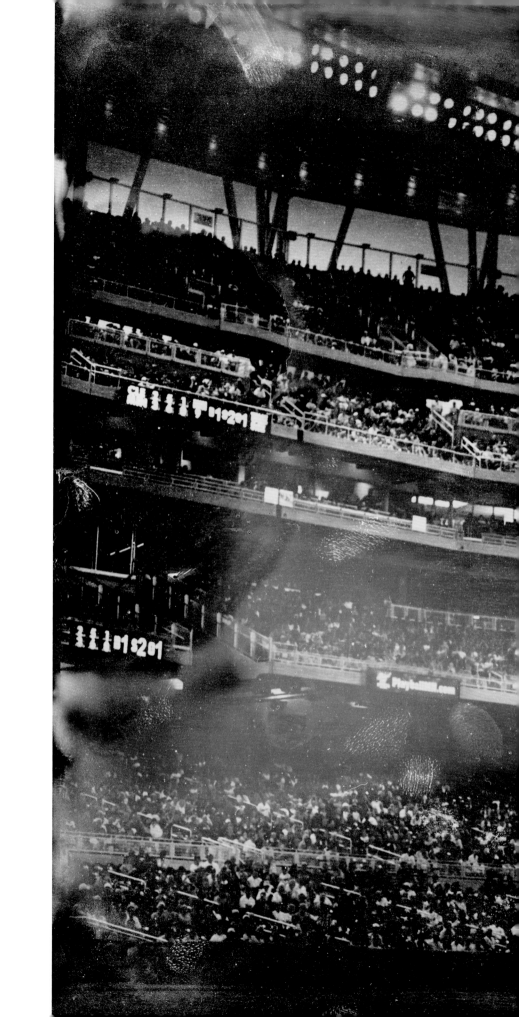

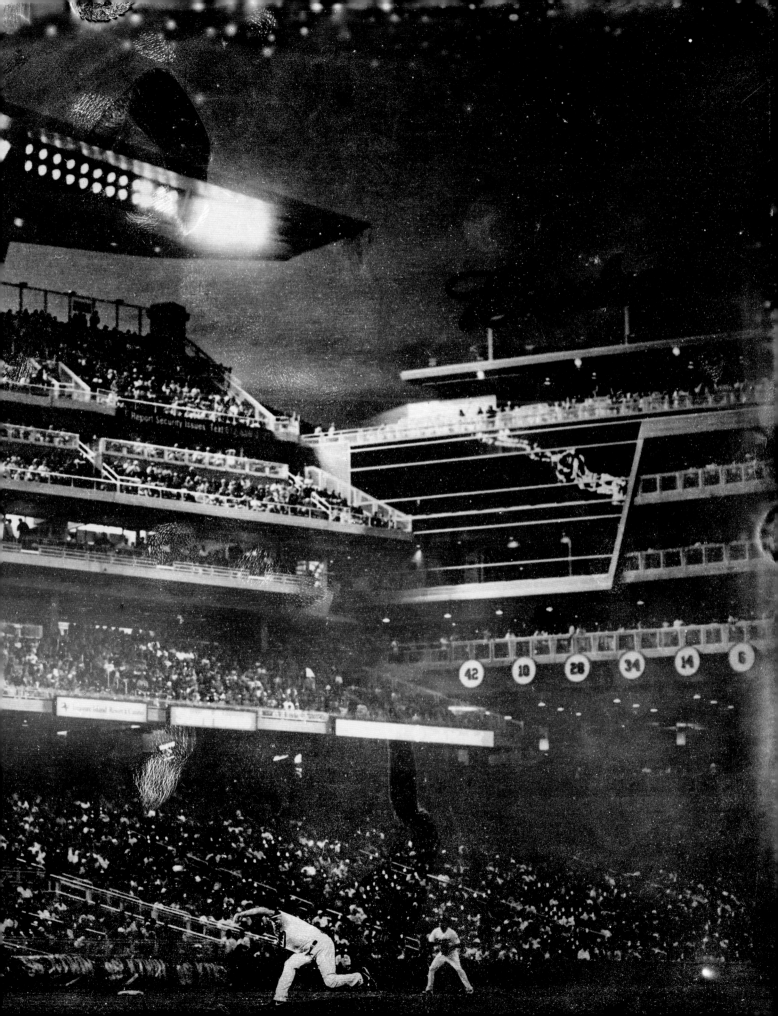

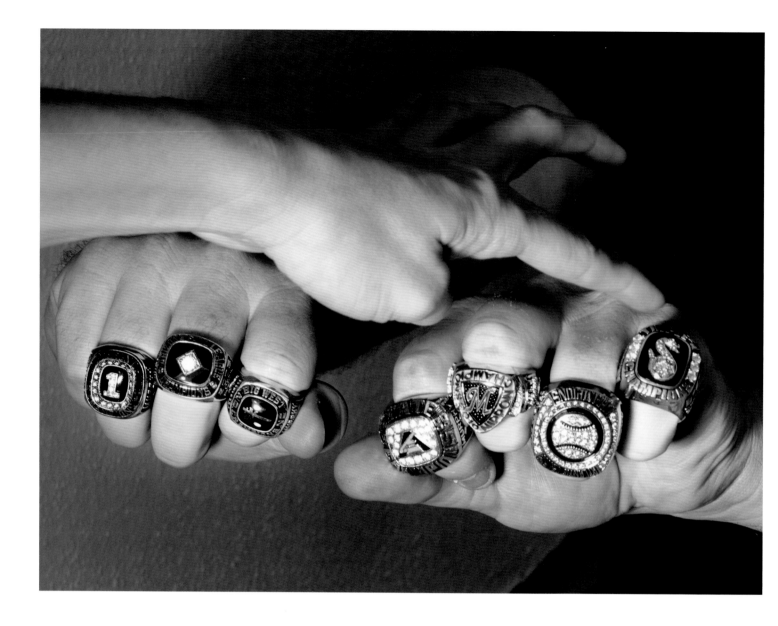

Thank God for YouTube. Someone had posted the triple. Gee assumed it was Jenkins, but didn't get the chance to confirm the fact before Jenkins died. He'd left the world while sleeping in his one-bedroom apartment in Idaho Falls. The TV was on. He'd never retired. He'd worked that day and was scheduled to work the next. He was eighty-one.

Five years later, Gee's at-bat for the Dodgers had been watched 361 times. About a hundred of those were Gee's daughter, Maisie, now four. She'd discovered it a month ago.

"Did you get any other hits?" she asked.

"Sure," Sheila said from the bathroom.

"Close the door when you do that," Gee said to his wife.

They were back in Missoula and Sheila was back in her old job. Gee's schedule was looser than hers, so he drove Maisie to pre-K and picked her up. Lately, because Sheila was doing sixty hours a week at the hospital, whenever she was home she wanted to be near Maisie and Gee, even while doing her business. She didn't close the door.

"I didn't get any more hits for this team," Gee told Maisie. "I played there two games, and went one for nine."

"But your daddy hit for all kinds of other teams," Sheila said from the bathroom, and now they could hear the toilet flush.

"Like the IronPigs," Maisie said. She loved the names. She knew them all: Mud Hens, Drillers, SeaWolves, Chukars.

"And the Owlz," Maisie said, stretching out the *z*.

"Right. Especially them," Sheila said, returning to the room, tying the drawstring on her pants. "He batted .412 there."

"I didn't," Gee murmured into Maisie's neck.

After Tulsa, Gee had driven a forklift for a while, then found work on a construction crew. He even did a few months working for Sheila's parents, trying to learn the cattle business. That's what first brought him to Missoula

Community College. He was enrolled in a husbandry class when he heard that the baseball team needed a coach.

He was too young, they said, and he had no experience coaching. But there was no one else remotely qualified, so he got the job. The team finished the last season 27–20. Most of the players were high school standouts, but weren't thinking beyond the Great Plains Community College League. But there was one kid, Alexander Rosales, who had something. Maybe not enough for the majors, but the fielding and body type to get him at least to Double-A.

One day he asked to meet with Gee. Gee's office was being fumigated, so they talked while walking around the track. A scout had approached him, Alexander said, just to feel him out about playing professionally.

"You played," Alexander said. "You're the only one I've ever met who played. What do you think I should do?" His eyes were upon Gee as they walked, and Gee was afraid to look back to him, for fear that Alexander's unblinking earnestness would cause him to say something ill-conceived. Alexander was smart. He was pre-law. And he was engaged, with a baby on the way. Gee tried to tell him it was his decision, a personal decision, a very personal and serious decision, when Alexander cut him off.

"Okay. But if you were to do it over again, would you play?"

Goddamnit, Gee thought. He thought of the parrot-green grass, the scolding sound of sprinklers, the holy and virtuous smell of wet dirt. He saw the long arc of a white ball in a blue sky. He saw kids leaning over the railing for autographs. He saw Guerrero, the Cuban phenom, holding his head, hit by a pitch thrown at 97 mph. There was The Bunt. The insults. The nicknames. There was the sound of eight thousand people cheering a walk-off double. There was the time Hennessey flew Gee out to see his debut with the Cardinals. There was McGeoghan's suicide.

"You know what," Gee said. "I honestly have no idea."

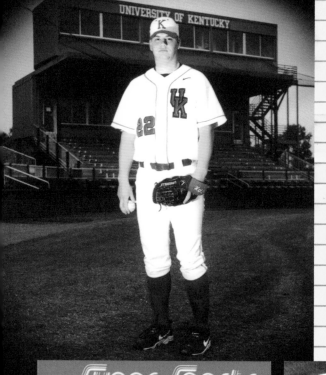

Joe Blanton

Oakland A's 2002 Draft
 Vancouver Canadians - 2002
 Modesto A's - 2002
 Kane County Cougars - 2003
 Midland Rockhounds - 2003
 Sacramento Rivercats - 2003/2004
 Oakland A's Sept. 2004 - July 2008

Philadelphia Phillies July 2008 - July 2012
Los Angeles Dodgers August 2012 - end of season
Los Angeles Angels of Anaheim 2013 - March 2014 // Retired
Kansas City Royals current (2015)
Pittsburgh Pirates 2015
Los Angeles Dodgers 2016

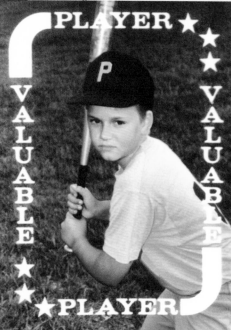

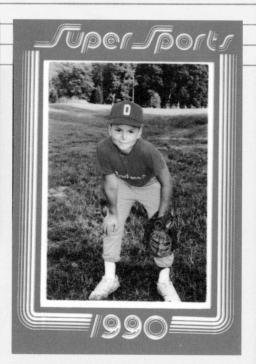

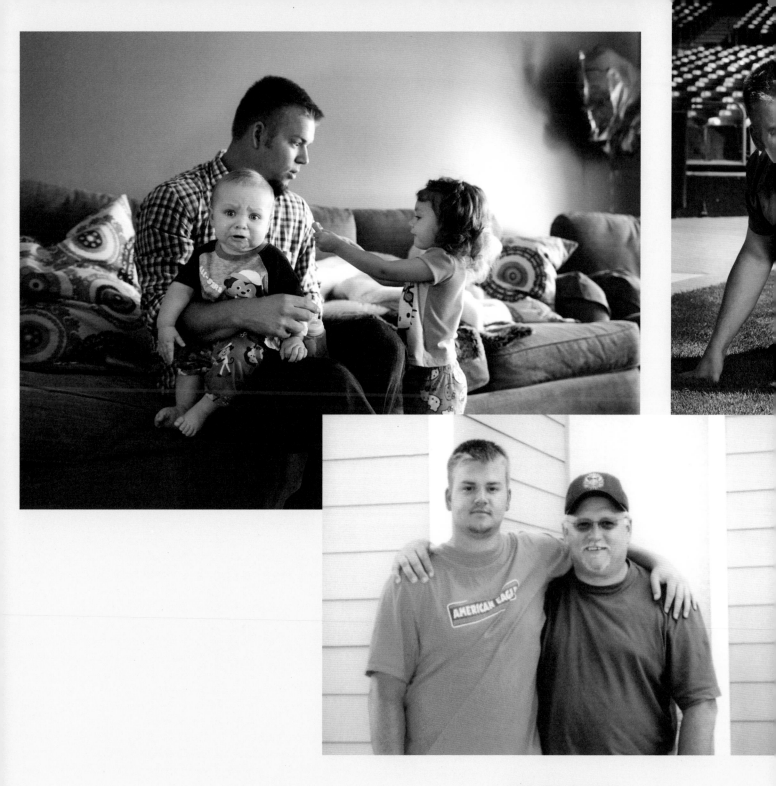

JOE BLANTON (b. 1980)

Position: Pitcher

Drafted: 2002, 1st round (24th pick) by the Oakland A's

Years playing baseball: 32

Seasons in minor leagues: 1

Seasons in major leagues: 12 (2 World Series)

League earnings: $38,698,500

Current career: Relief pitcher, Los Angeles Dodgers

Marital status / children: Remarried / 3

Career highlights: Hit first home run of Major League career in 2008 World Series for Philadelphia Phillies; 2015 World Series champion, Kansas City Royals

My career fortunately ran pretty smoothly until the spring training of 2014, when the Angels released me. After that I tried to play in the minor leagues again, for the first time since 2004. This did not go that well and after two weeks into the season I decided to retire and be with my family. My wife, LeeAndra, my daughters, and my son have all been fantastic through my career with all the moves and different cities I have played in. I decided to purchase a vineyard

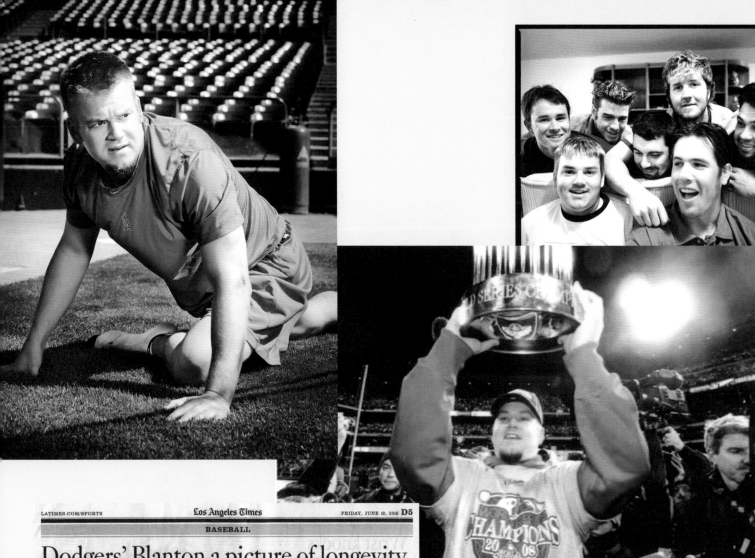

LATIMES.COM/SPORTS **Los Angeles Times** FRIDAY, JUNE 10, 2016 **D5**

BASEBALL

Dodgers' Blanton a picture of longevity

Right-hander is among the star subjects of a photo exhibit that tracks A's draft picks.

By BILL SHAIKIN

If he has some free time this weekend, Dodgers pitcher Joe Blanton could walk out of the team hotel in San Francisco, hop onto the subway and take a 30-minute ride to Walnut Creek to see an exhibition of photography.

He's in it.

Blanton, 35, is one of the star subjects of "Fantasy Life," which tells the story of the Oakland Athletics' 2002 draft class in images rather than statistics. The photos reveal the vulnerability of players trying to navigate a career path in which fame and fortune turn out to be the exception.

"It's pretty neat," Blanton said. "It's cool to see where guys are 10 years down the road. Some are coaches, some are insurance agents, some guys are still playing.

"It's probably normal for every team, but you get a picture to put

with what guys are doing."

The photographer was Tabitha Soren, a former MTV personality, who met the players in spring training in 2003. Her husband is Michael Lewis, whose book "Moneyball" was published that year. While Lewis focused on the inner workings of the A's braintrust, Soren was captivated by the newest class of players.

"I was so taken with all the hope and innocence on their faces," she said. "I also felt like these were the winners. These were the guys that got selected to be professional baseball players. I assumed, naively, that they were all going to end up playing in Oakland, or for a major league team."

When she learned that most of them would fall short of the majors — one in six MLB draft picks make it, even if only for a day, according to Baseball America — she found that arc so compelling that she committed to track 21 draft picks over time.

It took 13 years.

"I wanted not only the ascent," Soren said, "but the stepping away from baseball as well."

JOE BLANTON was out of the majors for a year after struggling with Angels in 2013.

"Most of my players," Soren said, "they were making $500 a week, for years and years and years."

Soren laughs off any notion that she is a baseball expert; at first, she said, she would say "outfit" rather than "uniform."

Blanton recalled how Soren explained that she wanted to track not only the careers of the players but "their physical changes, and if they were still in baseball, how the body might progress."

Said Soren: "One of my theories was that their bodies would change radically along the way, in some way, shape or form. That didn't actually work out. They all took care of themselves and looked good, week after week, year after year.

"Those pictures were not very transformative."

But Blanton had a long memory. In 2013, when he was pitching for the Angels and met Soren for a photo shoot, he wore a tight shirt, just like she had asked the prospects to wear a decade earlier.

"He had also lost a ton of weight," Soren said, laughing. "That was his way of making that

very obvious."

Soren is expanding the exhibit into a book, which will include background on each player, some of it written by the players themselves. The book is scheduled for publication next spring.

Blanton announced his retirement in 2014, after making two starts at triple-A. Soren had his career log complete — A's, Philadelphia Phillies, Dodgers and Angels — when she looked up at a television during a gym workout last summer.

"God, that looks a lot like Blanton," she thought.

He had come back, to the Kansas City Royals and Pittsburgh Pirates last season, and to the Dodgers this season, reinventing himself as a relief pitcher. That has Soren wondering how to finish the page in her book on Blanton.

"I'm hoping we don't go to press too early, because God knows what he could be doing then," she said. "He could be at his vineyard, or he could be in the World Series."

bill.shaikin@latimes.com
Twitter: @BillShaikin

in Napa Valley and try a hand at my second passion behind baseball: wine. I was able to have a summer to spend with my family and enjoy life away from baseball. That is, until a new neighbor moved in down the street who also happened to play baseball. He needed someone to play catch with in the winter so I volunteered to help him. Little did I know that this was going to restart my career after being retired throughout the 2014 season, and with no plans of returning to the game. The more

we played catch, the more I started to realize that baseball was something I might want to give one last try. I enjoyed playing baseball as a game again, without any pressure of it being a job. I realized I had lost that feeling along the way during my professional career.

I was fortunate enough to get an opportunity with the Kansas City Royals for the spring of 2015. I started back in the minor leagues again with a clear mind and lots of determination. Things worked out this time

around as a reliever, instead of as a starting pitcher, and I'm now a set-up man in the big leagues with the Dodgers. A new chapter has begun in my baseball career and after being away from the game for a year, I feel blessed to have a second chance. ★

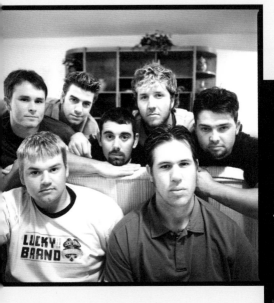

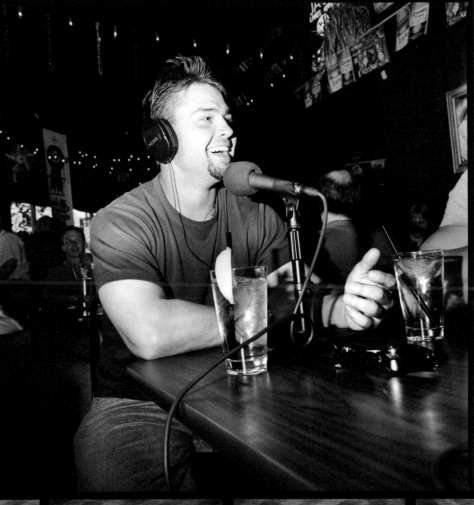

Positions: First baseman, outfielder, designated hitter

Drafted: 2002, 1st round (16th pick) by the Oakland A's

Years playing baseball: 32

Seasons in minor leagues: 1

Seasons spent in major leagues: 13

League earnings: $92,251,500

Current career: Free agent

Marital status / children: Married / 2

Career highlights: 2009 World Series champion, New York Yankees; 2010 All-Star

NICK SWISHER (b. 1980)

At six years old, in Waterloo, Iowa, I remember my mountain of a father looking down at me on my awesome red banana-seat bike and asking me, "What do you want to do when you grow up?" My response: "I want to play in the big leagues just like you did, Dad," and I'll never forget his answer: "You want it? You are gonna have to work for it!"

That is something that I never forgot and took to heart. I had to work hard for everything I had in the game of baseball. I didn't have the most

Oakland places Swisher on 15-day disabled list

Associated Press

OAKLAND, Calif. — Nick Swisher crashed into the right-field wall so hard he nearly threw up on the field, then later drifted in and out of consciousness while in the emergency room.

The Oakland Athletics placed the rookie outfielder on the 15-day disabled list Monday with an injured right shoulder, but a CT scan showed he didn't sustain any head trauma in the collision Sunday.

"The shoulder was minimal," Swisher said. "They said, 'We have to do tests on your brain.' I said, 'Just make sure one is in there.'"

Swisher, the A's primary right fielder, left in the third inning of Sunday's 3-2 win over Seattle after crashing into the wall chasing Jeremy Reed's triple. Swisher has a grade 1 sprain of his AC joint, which connects the shoulder to the collarbone, trainer Larry Davis said.

Swisher, who also slammed his head into the wall, underwent tests on his right shoulder and his head at a hospital.

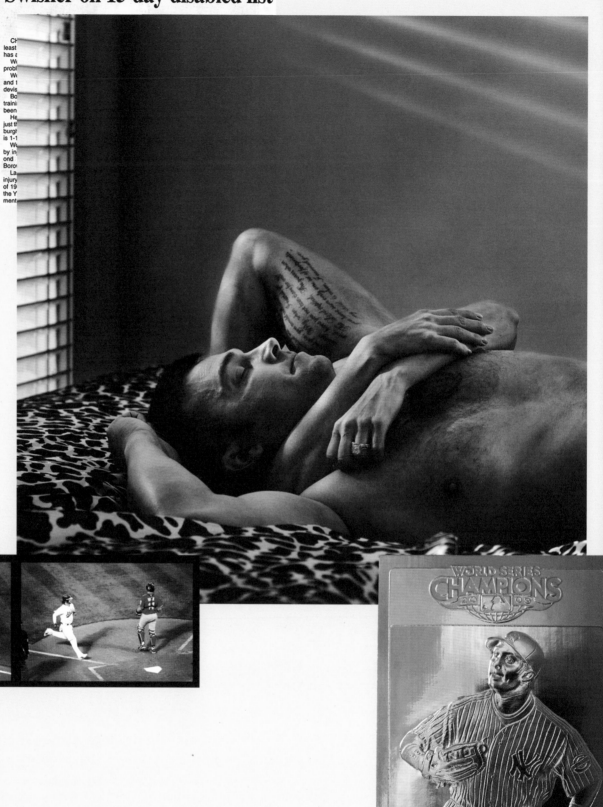

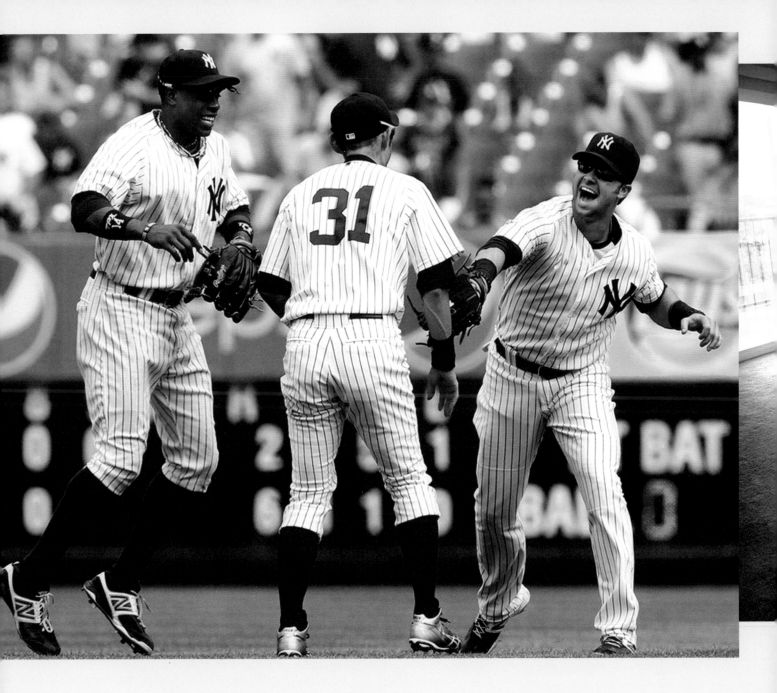

talent or the greatest arm. I wasn't the fastest and didn't have the ability to hit the ball five hundred feet. But the one thing I did have was a driving, burning force inside me that would not accept failure as an option. I also had luck on my side.

Timing is a lot in life and in 2004 timing was on my side. I was hot in Triple-A, and the everyday right fielder for the Oakland A's at that time broke his thumb. I finally had my chance. And once I got it I never looked back!

I loved Oakland, the city and organization that gave me my shot. We had an awesome group of young studs waiting to make their mark on the game. We all came up together. (If you've never heard of us, check out the book *Moneyball*. It explains a lot.) We didn't stress. We just went out there every day and left it all on the field! We were good, too. We didn't win a World Series but we brought fun and a winning attitude to the Bay Area.

I was playing a game for a living and I never

wanted to forget that. But don't get me wrong: when it comes to competition, I don't care if we are playing Game Seven of the World Series or checkers, I want to beat you!

After a brief stay on the South Side of Chi-Town for the White Sox in 2008, my time had come . . . off to the Big Apple! A place that any player would be lucky to play. I will always love New York! I loved the bright lights, the passion and pride the organization had, wearing that "NY" on my chest and *winning*! That's

exactly what we did when I was there. We *won*! To be able to etch your name along with the greats of the past in New York was *badass*!

I wanted to be something no one in New York had ever seen. I didn't just want to reach the fans. I wanted to touch them. Whether it was a high five or a big hug, I wanted people to remember me. Not only for playing the game hard and giving everything I had, but for going about my business with a monster smile on my face and loving every single second!

From being a first-round draft pick to being an All-Star and then a World Series champ, it's been one crazy, amazing ride. One that any person would give their left arm to live. I've had my ups and downs through the years, but as my grandpa would say, "When you are doing what you love every day you should be considered a lucky man." As I like to say, "It's seventy-five and sunny in my world!" ★

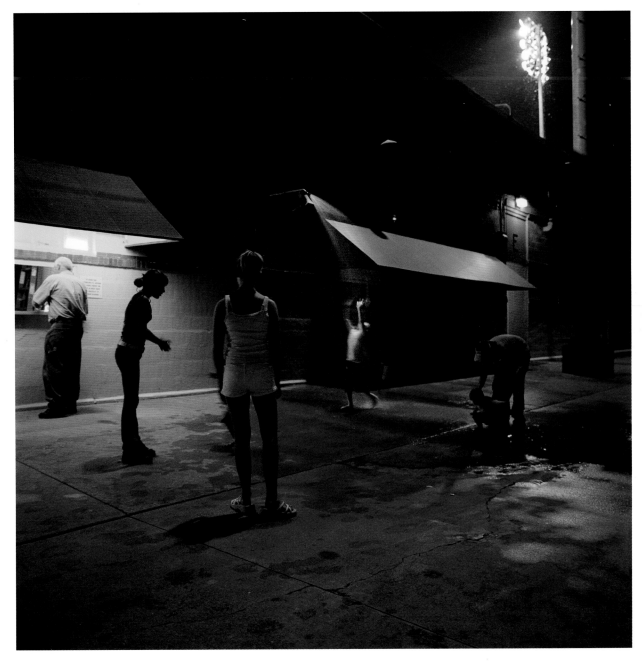

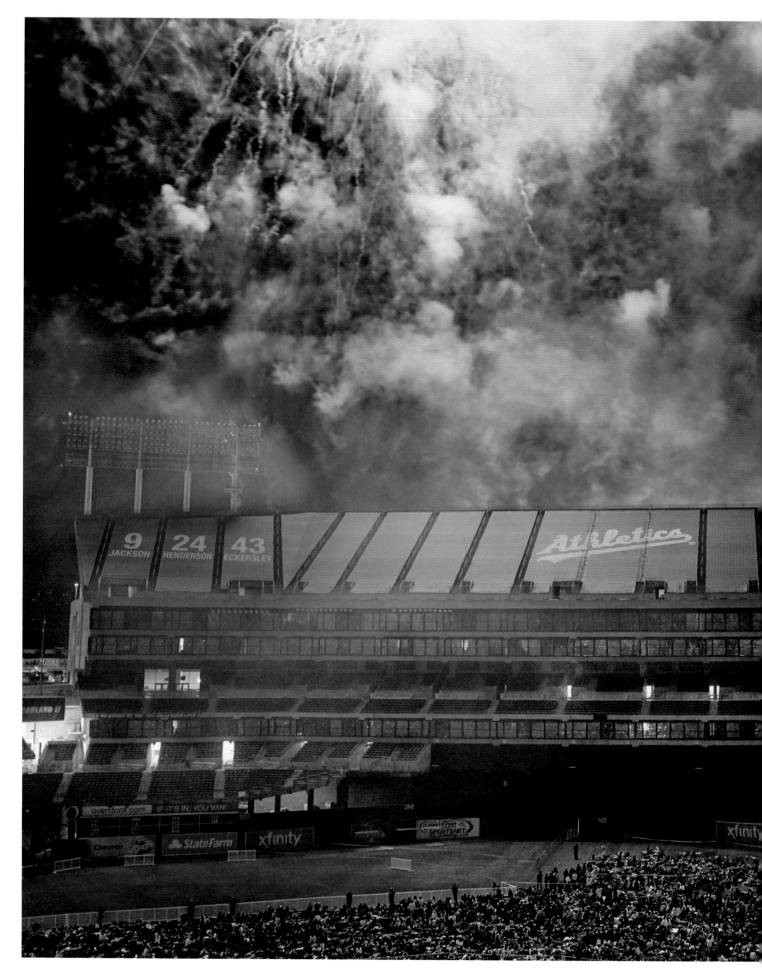

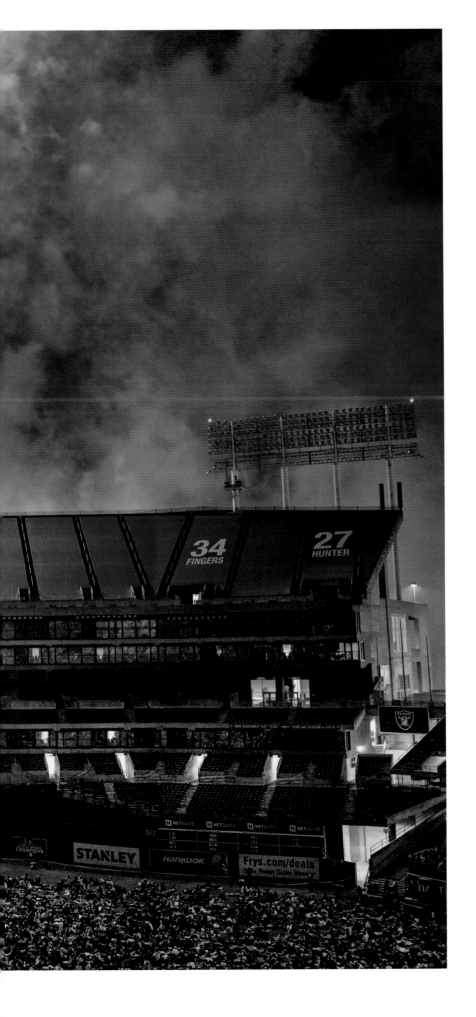

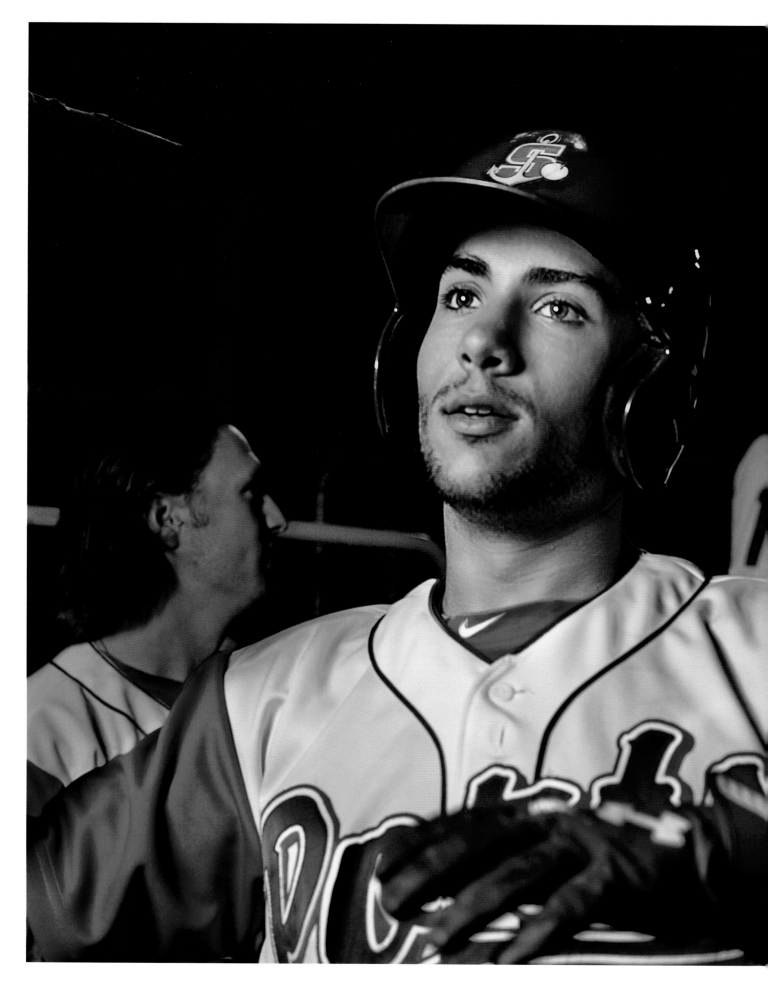

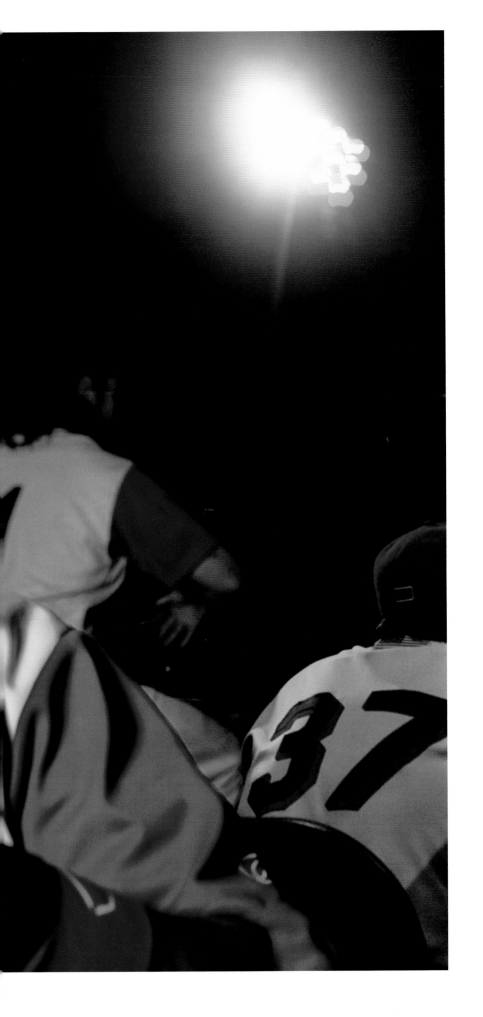

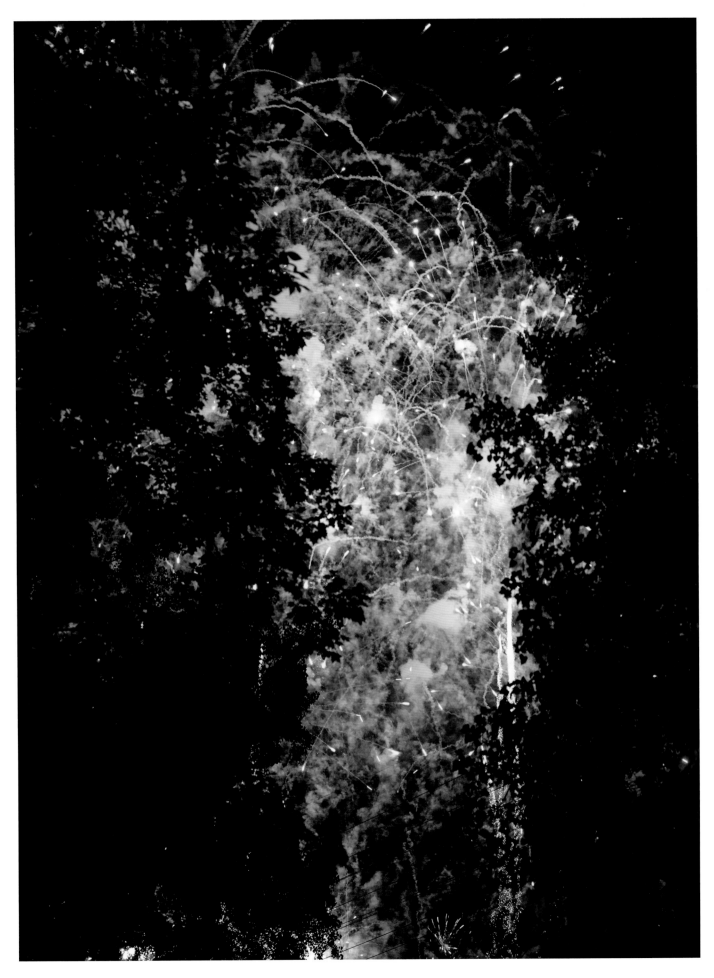

In 2002, Tabitha Soren began photographing the new draft class of the Oakland A's, working with a range of photographic media, including digital, traditional film, and vintage-style tintypes. She went on to follow the trajectory of their careers, in and out of baseball, over a dozen seasons since their famous draft year. Ten of that group of twenty-one players are presented in this book. Included in each section focusing on the individual players, all family photos, baseball cards, and other ephemera have been supplied courtesy the individual players and their families unless otherwise noted here; images by Soren that appear in those sections are underlined.

Frontispiece: Steve Stanley, Oakland A's outfielder, 2004. Professional baseball career: Oakland A's, 2002–8; current career: State Farm insurance agent

4–5: Larry DiVito (far right) and groundskeeping crew for the Minnesota Twins, Minneapolis, 2013

7: Clete Thomas, Trevor Plouffe, and Ryan Doumit, Minnesota Twins, Minneapolis, 2013

8–9: Nick Swisher (at bat), Cleveland Indians, faces Kevin Correia (pitcher), Minnesota Twins, Minneapolis, 2013

10: San Jose Giants fans, California, 2014

11: Fans with Justin Morneau, Minnesota Twins first baseman, Minneapolis, 2013. Professional baseball career: Minnesota Twins, Pittsburgh Pirates, Colorado Rockies, Chicago White Sox, 2002–16; current career: Chicago White Sox first baseman

12–13: Release day, Oakland A's spring training, Scottsdale, Arizona, 2014

14–15: Durham Bulls Athletic Park, North Carolina, 2014

16: Cotton candy, Target Field, Minneapolis, 2013

18, *left to right*: Lee and Steve Obenchain, South Bend, Indiana, 1986 • Steve Obenchain, Oakland A's pitcher, Fall League, Scottsdale, Arizona, 2004. Professional baseball career: Oakland A's minor league 2002–6; current career: supervisor of portfolio support services, Donaldson Capital Management, Evansville, Indiana • Steve Obenchain, Evansville Black Sox, Indiana, 1997

19, *left to right*: The Obenchain family, Hayward, California, 2014 • Steve Obenchain and his twelve-year-old all-star team, Henderson, Kentucky, 1993 • Steve Obenchain, Evansville Black Sox, Indiana, 1999

20, *left to right*: Steve and Hailey Obenchain, Scottsdale, Arizona, 2004 • Drew Dickinson and Steve Obenchain, Midland RockHounds, Texas, 2005

21, *left to right*: Chris Shank and other Massachusetts high school all-stars, 2000 • Chris Shank and his White Sox teammates, Westminster, Massachusetts, 1988

22–24: Chris Shank, annual portrait contact sheet, Manchester, New Hampshire, 2013

22, *left to right*: Professional draft announcement for Chris Shank in *Sentinel & Enterprise*, 2002 • Newspaper articles saved by Joyce Shank about her son Chris's college baseball career, *Sentinel & Enterprise*, 2000 • Chris Shank's grandfather Pepere Normandin, 1942

23, *left to right*: Don and Chris Shank, Scottsdale, Arizona, 2004 • Coach Chris Shank, Southern New Hampshire University, Manchester, New Hampshire, 2013

24, *left to right*: Chris Shank, Manchester, New Hampshire, 2013 • Chris Shank's royalty check from Topps baseball cards, 2002 • Chris Shank, Oakland A's pitcher, Visalia, California, 2004. Professional baseball career: Oakland A's, 2002–5; current career: head baseball coach, New England College, Henniker, New Hampshire

25: Field equipment under the stadium seats at Rickwood Field, the oldest surviving professional baseball park in the United States, Birmingham, Alabama, 2013

26: Tobacco and bubble gum, Cleveland Indians dugout, 2013

27: Pinnacle High School, Phoenix, 2014

28–29: Modesto Nuts bull pen, Modesto, California, 2014

30: Pinnacle High School, Phoenix, 2014

31: Kane County Cougars warm-up, Clinton, Iowa, 2003

33: Motel pool, spring training, Scottsdale, Arizona, 2014

34, 35: Brian Stavisky, Oakland A's outfielder and designated hitter, Scottsdale, Arizona, 2005. Professional baseball career: Oakland A's, Los Angeles Angels, Philadelphia Phillies, 2002–10; current career: sales analyst, Dresser-Rand, Horsham, Pennsylvania

37: Jared Burton, Minnesota Twins relief pitcher, Minneapolis, 2013. Professional baseball career: Oakland A's, Cincinnati Reds, Minnesota Twins, 2002–15; current career: free agent

38–39: Steve Stanley, Midland RockHounds, Midland, Texas, 2005

40: Coach Drew Dickinson, Minneapolis, 2013

42, *left to right*: Ben Fritz, Blossom Valley Pony league, San Jose, California, 1988 • Ryan, Jason, Ben, and Scott Fritz, San Jose, California, 1990 • Ben Fritz's knee surgery x-ray, 2010

43: Ben Fritz, Sacramento River Cats pitcher, California, 2007. Professional baseball career: Oakland A's minor league 2002–7; current career: minor league manager, San Diego Padres

44: Ben Fritz rehabbing after Tommy John surgery, Scottsdale, Arizona, 2005

45, *left to right*: Drew Dickinson, Cedarville, Illinois, 1982 • Drew Dickinson, Oakland A's pitcher, Scottsdale, Arizona, 2005. Professional baseball career: Oakland A's minor league 2002–5; current career: pitching coach, University of Illinois

46, *left to right*: Drew Dickinson, Shawn Kohn, and Matt Lynch, Fairfield Inn, Plano, Texas, 2005 • Drew Dickinson, Midland RockHounds, Midland, Texas, 2004 • Drew Dickinson with team trainer Javy Alvidrez, Oakland A's training room, Scottsdale, Arizona, 2006

47, *left to right*: Drew Dickinson boarding Kane County Cougars team bus, Clinton, Iowa, 2003 • Drew Dickinson, Midland RockHounds, Midland, Texas, 2004

48: Coach Drew Dickinson, College World Series, Minneapolis, 2013

49: Clinton LumberKings fan, Clinton, Iowa, 2003

50: Cleveland Indians vs. Minnesota Twins, Target Field, Minneapolis, 2013

51: Riverview Stadium, Clinton, Iowa, 2003

53: Brian Stavisky, Rochester, New York, 2014

54–55: Empty seats at Banner Island Ballpark, Visalia Rawhide vs. Stockton Ports, Stockton, California, 2014

56–57: Jonathan Joseph, Stockton Ports pitcher, California, 2014. Professional baseball career: Oakland A's minor league 2006–15; current career: free agent

58–59: Stockton Ports vs. San Jose Giants, San Jose, California, 2014

60–61: Nick Swisher, Cleveland Indians first baseman, 2013. Professional baseball career: Oakland A's, Chicago White Sox, New York Yankees, Cleveland Indians, Atlanta Braves, 2002–16; current career: free agent

62–63: Daniel Robertson, Stockton Ports shortstop, California League Northern Division Championship, Visalia, 2014. Professional baseball career: Oakland A's, Tampa Bay Rays minor league teams 2012–16; current career: Durham Bulls infielder

64: Jaycob Brugman, Stockton Ports outfielder, Visalia, California, 2014. Professional baseball career: Oakland A's minor league 2013–16; current career: Nashville Sounds outfielder

66, *left to right*: Brian Stavisky's professional baseball career, 2002–10; Brian Stavisky, Most Valuable Player, California League, Modesto, California, 2003

67, *left to right*: Brian Stavisky, annual portrait contact sheet, Scottsdale, Arizona, 2004 • Brian Stavisky, Oakland A's, Scottsdale, Arizona, 2004

68: Brian Stavisky, Cape Cod Baseball League, Hyannis, Massachusetts, 2001

69, *left to right*: Mark Kiger, Carlsbad, California, 2013 • Mark Kiger, Carlsbad, California, 2013 • Mark Kiger, Midland RockHounds second baseman, Midland, Texas, 2004. Professional baseball career: Oakland A's, New York Mets, Seattle Mariners minor league teams, 2002–9; current career: little league travel ball coach, Beaumont, Texas

70, *left to right*: Mark Kiger, Oakland A's, first spring training, Scottsdale, Arizona, 2003 • Mark Kiger comparing his injured hand, Carlsbad, California, 2013

71: Mark Kiger, Carlsbad, California, 2013

72, *left to right*: Mark Kiger, John McCurdy, and Brant Colamarino, Oakland A's spring training, Fairfield Inn, Scottsdale, Arizona, 2004 • Jaxson and Faith Kiger, Keegan, Brogan, and Sue Casey, Carlsbad, California, 2013 • Mark Kiger, *Midland Reporter-Telegram* headline, May 3, 2005

73: Splash and the Stockton Ports, (left to right) Seth Streich, Chad Pinder, Ryan Lipkin, Bobby Crocker, and coach Brian McArn, 2014

74: Marco Scutaro, San Francisco Giants infielder, 2014. Professional baseball career: New York Mets, Oakland A's, Toronto Blue Jays, Boston Red Sox, Colorado Rockies, San Francisco Giants 2002–15; current career: retired

75: Visalia Rawhide fans, California League Championship, Stockton, 2014

76: Billy McKinney, Stockton Ports outfielder, San Jose, California, 2013. Professional baseball career: Oakland A's, Chicago Cubs, New York Yankees minor league teams 2013–16; current career: Trenton Thunder outfielder

77: Billy McKinney and Matt Olson, Stockton Ports, San Jose, California, 2013

78: Aaron Rowand and Cody Ross, San Francisco Giants, 2010 World Series Champions, 2014

79: Nick Swisher and Jay Payton play-fight, Oakland, California, 2005

80–81: Hitting coach Mark McGwire, Los Angeles Dodgers, restrained by third base coach Matt Williams and manager Kirk Gibson, Arizona Diamondbacks, Los Angeles, 2013

82: Coach Ryan Christenson with Jaycob Brugman, Wade Kirkland, Ryan Lipkin, Bobby Crocker, and Seth Streich, Stockton Ports, San Jose, California, 2014

83: Minnesota Twins fans, Minneapolis, 2013

84–85: Gene Tenace waved safe, Oakland A's vs. Los Angeles Dodgers (1979), 2014

86: Nick Swisher, New York Yankees, 2009

87: Derek Jeter's last game in Yankee Stadium, New York, 2014

88: "We are all melting ice cubes." Albuquerque, New Mexico, 2013

90, *left to right*: Padres Little League baseball card, Hueytown, Alabama, 1984 • Coach Neal Brown, Jeremy Brown, and teammates, Hueytown, Alabama, 1989 • Jeremy Brown, Oakland A's catcher, first spring training at major league camp, Scottsdale, Arizona, 2003. Professional baseball career: Oakland A's, 2002–7; current career: private baseball coach and college student

91, *left to right*: Jeremy Brown, Midland RockHounds, Fairfield Inn, Plano, Texas, 2005 • Thank-you note from Little League player John Aldrich to Jeremy Brown's dad, coach Neal Brown, Hueytown, Alabama, 1989 • Jeremy Brown, Bessemer, Alabama, 2013

92, *left to right*: Jeremy Brown, Sacramento River Cats, 2006 • Jeremy Brown, final season, Sacramento, California, 2007

93, *left to right*: Mark Teahen, Kansas City Royals Little League, Yucaipa, California, 1987 • Mick, Matt, Mike, and Mark Teahen, Glendora, California, 1986

93–94: Mark Teahen, Kansas City Royals vs. Oakland A's, California, 2005

94, *left to right*: Mark Teahen, Kansas City Royals outfielder, third baseman, and first baseman, 2009. Professional baseball career: Oakland A's, Kansas City Royals, Chicago White Sox, Toronto Blue Jays, Washington Nationals, Arizona Diamondbacks, Texas Rangers, San Francisco Giants, 2002–14; current career: co-owner, Sorso Wine Room, Scottsdale, Arizona • Mark Teahen, Chicago White Sox, Scottsdale, Arizona, 2010

95, *left to right*: Mark Teahen, Chicago White Sox spring training, Glendale, Arizona, 2010 • Mark Teahen, York Revolution (independent league), Somerset, New Jersey, 2013 • Mark Teahen in his boyhood bedroom, Yucaipa, California, 2004

96, *left to right*: Mark Teahen, Kansas City Royals, Fall League, Scottsdale, Arizona, 2004 • Mark Teahen, Kansas City Royals, Fall League, Scottsdale, Arizona, 2004

97: Disposable cups, Clinton, Iowa, 2003

98: Jed Morris, Oakland A's catcher, Scottsdale, Arizona, 2013. Professional baseball career: Oakland A's, 2002–8; current career: Eastern University Baseball Coach, St. David's, Pennsylvania

99: Jose Reyes, Toronto Blue Jays shortstop, with trainer George Poulis, Toronto, 2013. Professional baseball career: New York Mets, Miami Dolphins, Toronto Blue Jays, and Colorado Rockies, 2002–16; current career: New York Mets shortstop

100–101: Cliff Lee, Texas Rangers pitcher, Fort Worth, 2010. Professional baseball career: Montreal Expos, Cleveland Indians, Seattle Mariners, Texas Rangers, Philadelphia Phillies, 2002–16; current career: Philadelphia Phillies pitcher

102: Daniel Robertson, Stockton Ports dugout, Modesto, California, 2014

104–5: Boston Red Sox, 2014

106–7: San Jose Giants fans, California, 2014

108–9: Glen Perkins, Minnesota Twins pitcher, Minneapolis, 2013. Professional baseball career: Minnesota Twins 2006–16; current career: Minnesota Twins pitcher

110–11: Rain delay, Somerset, New Jersey, 2013

112: Bill Murphy's baseball championship rings, Riverside, California, 2014. Professional baseball career: Arizona Diamondbacks, Toronto Blue Jays, 2007–9; current career: retired

114, *left to right*: Joe Blanton, University of Kentucky, Lexington, 2001 • Joe Blanton's professional baseball career, 2002–16 [active as of 2017] • Joe Blanton, Little League portraits, 1989/1991/1990

115, *left to right*: Mateo, Joe, and Leyla Blanton, Pleasanton, California, 2013 • Joe Blanton Jr. and Sr., Sacramento, California, 2004

116, *left to right*: Joe Blanton, Los Angeles Angels starting pitcher, Oakland, California, 2013. Professional baseball career: Oakland A's, Philadelphia Phillies, Los Angeles Angels, Kansas City Royals, Pittsburgh Pirates, Los Angeles Dodgers, 2002–16; current career: Los Angeles Dodgers relief pitcher • *Los Angeles Times*, 2016 • Screenshot of Joe Blanton after winning the World Series with the Philadelphia Phillies, 2008

116–17, *left to right*: Members of the 2002 Oakland A's draft class (clockwise from top left): Mark Teahen, Drew Dickinson, Jeremy Brown, Jared Burton, Nick Swisher, Ben Fritz, and Joe Blanton, Phoenix, 2004

117, *left to right*: Nick Swisher, Oakland A's, spring training press interview, Phoenix, 2004 • Nick Swisher, home run against Kansas City Royals, Oakland, California, 2006

118, *left to right*: *Oakland Tribune*, 2005 • Nick and Joanna Garcia Swisher, Los Angeles, 2016 • Nick Swisher, New York Yankees World Series baseball card, 2009

119: Curtis Granderson #14, Ichiro Suzuki #31, and Nick Swisher #33 of the New York Yankees celebrate after defeating the Seattle Mariners at Yankee Stadium on August 5, 2012 in the Bronx borough of New York City. Photo by Jim McIsaac/Getty Images

120, *left to right*: Nick Swisher, Sacramento River Cats, California, 2004 • Nick Swisher and Johnny Damon, New York Yankees Topps baseball card, 2009 • Nick Swisher before Locks of Love hair donation, Oakland, California, 2006 • *New York Post*, 2016

121: Record high temperatures, Riverview Stadium, Clinton, Iowa, 2003

122–23: Night on the Green fireworks, Oakland, California, 2014

124–25: Matt Olson, Stockton Ports first baseman and outfielder, Stockton, California, 2014. Professional baseball career: Oakland A's minor league teams 2012–16; current career: Oakland A's first baseman and outfielder

127: Night game, Minneapolis, 2013

133: Tabitha Soren (second row from bottom, third from right) and the Pirates Tee Ball Team, Hahn Air Base, Germany, 1972

135: Billy Beane, San Diego, 1971. Professional baseball career: New York Mets, Minnesota Twins, Detroit Tigers, Oakland A's 1984–89; current career: General Manager, Oakland A's

136: Mark Teahen, Kansas City Royals, Fall League, Surprise, Arizona, 2004

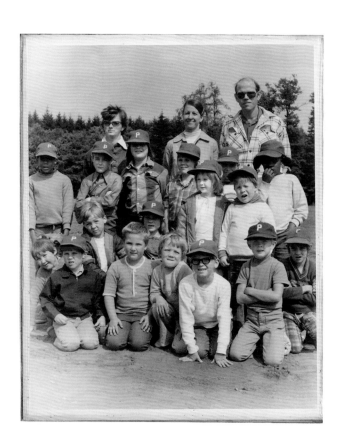

TABITHA SOREN left a successful career in television in 1999 to start another one as a photographer. Her work is included in public collections such as the Indianapolis Museum of Contemporary Art; Los Angeles County Museum of Art; New Orleans Museum of Art; Oakland Museum of California; Ogden Museum of Southern Art, New Orleans; Pier 24 Photography, San Francisco; and Transformer Station, Cleveland. Her work has been featured in *Blink*, *California Sunday Magazine*, *Dear Dave*, *ESPN The Magazine*, *McSweeney's*, *New York*, *New York Times Magazine*, *Slate*, *Sports Illustrated*, and *Vanity Fair*. She is represented by the Kopeikin Gallery, Los Angeles.

DAVE EGGERS is the author of eleven books, including most recently *Heroes of the Frontier* (2016), *Your Fathers, Where Are They? And the Prophets, Do They Live Forever?* (2014), *The Circle* (2013), and *A Hologram for the King* (2012), which was a finalist for the National Book Award for Fiction.

ACKNOWLEDGMENTS

Thanks to: Brian and Megan Camp, Dave Eggers, Lisa Foote, Jeff Freedman, Keith Lieppman, Samantha Marlow, Lesley Martin, Chris McCall, Kellie McLaughlin, Andy Pilara, Ted Polakowski, and Anne Schlatter.

For teaching me about baseball: John Baker, Joe Blanton, Jeremy Brown, Jared Burton, Brant Colamarino, Drew Dickinson, Chris Dunwell, Ben Fritz, Mark Kiger, Shawn Kohn, Shane Komine, John McCurdy, Jed Morris, Bill Murphy, Steve Obenchain, Chris Shank, Steve Stanley, Brian Stavisky, Nick Swisher, Mark Teahen, and Lloyd Turner.

And the players' families who helped me organize all the logistics: Meghan, Brooklyn, and Fiona Baker; LeeAndra, Adalia, Leyla, and Mateo Blanton; Shelli, Jarrett, and Ella Brown; Jill Burnham; Sue, Keegan, and Brogan Casey; Amber, Colby, and Giada Colamarino; Courtney Fritz; Faith and Jaxson Kiger; Brooke, Channing, Wesley, and Hadley Kohn; Jodi Nakama Komine and Kingston and Benjamin Komine; Kristin McCurdy; Genevieve, Jonah, and Ivy Morris; Natalie Calle Murphy; Erin, Hailey, Emily, Ryan, Jacquelyn, and Molly Obenchain; Beki Rush; Mary, Grayson, and Ainsley Shank; Brooke, Grace, Lily, and Mia Stanley; and Lauren, Mac, and Cal Teahen.

And the players' parents who trusted me with their family photos: Stephanie and Dave Baker, Carolyn and Joe Blanton Sr., Neal and Lila Brown, Harold and Debra Dickinson, Jim and Susan Morris, Don and Joyce Shank, Dan and Mary Stavisky, and Michael and Martha Teahen.

Oakland A's Backup: Maril Adrian, Catherine Aker, Zak Basch, Debbie Gallas, Webster Harrison, Chad Huss, Eric Kubota, Matt Lynch, Jason Perry, Pam Pitts, Bob Rose, Betty Shinoda, and Valerie Vanderheyden.

For letting me invade the Stockton Ports dugout: Ryan Christenson, Pat Filippone, Brian McArn, A. J. Seeliger, Travis Tims, and John Wasdin.

And to the 2014 Ports: Tim Alderson, Donny Barnes, Jaycob Brugman, Scott Carter, Matt Chapman, Rodolpho Fernandez, Ryon Healy, Jonathan Joseph, Wade Kirkland, Ryan Lipkin, Bruce Maxwell, Billy McKinney, Renato Nunez, Matt Olson, Chad Pinder, Tyler Richardson, Daniel Robertson, Jake Sanchez, Seth Streich, Beau Taylor, Ben Taylor, and Bobby Wahl.

To all the former players who opened up their scrapbooks for me: Eric Carlson, Scott and Bitsy Hatteberg, Katie and Jason Kaneko, Bruce Keilin, Nick Lavrov, Michael Saaf, and David Wampler.

For having my back: Susanna Aaron, Jamie and Michael Lynton, and Phil Morrison.

For being an extra set of eyes: Katie Baum, Aya Brackett, Frish Brandt, Julie Casemore, Julian Cox, Judy Dater, Jeffrey Fraenkel, Jim Goldberg, Katy Grannan, Todd Hido, Darius Himes, Maren Levinson, Susan Meiselas, Richard Misrach, Rebecca Morse, Alex Nemerov, Laura Plageman, Amy Regalia, Doug Rickard, and Griff Williams.

For working on the 2015 exhibition at Kopeikin Gallery: Allison Crain, Claire Ferrari, Dirk Hatch, and all at Lightwaves; Stefan Kirkeby, and all at Smith Anderson North; Paul Kopeikin, Steve Larios, and all at Finishing Concepts; Ray Olson, Hendrick Paul, Troy Peters, and all at Gallery 16; Masumi Shibata; and Steve Sprinkel.

Assistants along the way: Lauren Crew, Erica Deeman, Hannah Hughes, and Sophie Maher.

Assistants on the road: Steven Cohen, Chris Gianunzio, Casey Horvitz, Joshi Radin, Nick Rogers, Maggie Stockman, Andrew Thames, and Stephen Wade.

For helping me connect the dots: Joni Binder, Scott Carter, Seth Curcio, Jeff and Marla Garlin, Allie Haeusslein, Simon Hunegs, Maria Jacinto, Duff Lambros, Jamie Lunder, Joshua Machat, Margot Magowan, Brad Mangin, Nion McEvoy, Dustin Morse, Rob Neyer, Erin O'Toole, Matthew Snyder, Art Streiber, and Maritza Yoes.

For assignments along the way: Jacqueline Bates, Steve Fine, Karen Frank, Paul Reyes, Kathy Ryan, and Allison Wright.

DEDICATION

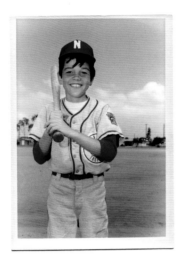

FOR MICHAEL AND BILLY,
MY FAVORITE BROMANCE.

Fantasy Life
Baseball and the American Dream
Photographs by Tabitha Soren
Five Linked Stories by Dave Eggers

Editor: Lesley A. Martin
Designer: Bob Aufuldish, Aufuldish & Warinner
Production Director: Nicole Moulaison
Production Manager: Thomas Bollier
Assistant Editor: Samantha Marlow
Senior Text Editor: Susan Ciccotti
Copy Editor: Sally Knapp
Work Scholars: Simon Hunegs, Melissa Welikson

Additional staff of the Aperture book program includes:
Chris Boot, Executive Director; Sarah McNear, Deputy Director;
Amelia Lang, Managing Editor; Kellie McLaughlin, Director of Sales
and Marketing; Richard Gregg, Sales Director, Books; Taia Kwinter,
Assistant to the Managing Editor

Special thanks:
Fantasy Life was made possible, in part, with generous support
from A's Community Fund, Robert Mailer Anderson, and James H.
Clark Charitable Foundation.

Aperture also wishes to thank the Schley Family Foundation
and Barry and Amber Zito for their contributions to making this
project possible.

Fantasy Life is part of Aperture Foundation's First Book Initiative
to publish new work by emerging artists.

First edition, 2017
Printed by Artron in China
10 9 8 7 6 5 4 3 2 1

Library of Congress Control Number: 2016957039
ISBN 978-1-59711-385-4

To order Aperture books, contact:
+1 212.946.7154
orders@aperture.org

For information about Aperture trade distribution worldwide,
visit: www.aperture.org/distribution

aperture

Aperture Foundation
547 West 27th Street, 4th Floor
New York, N.Y. 10001
www.aperture.org

Aperture, a not-for-profit foundation, connects the photo
community and its audiences with the most inspiring
work, the sharpest ideas, and with each other—in print,
in person, and online.

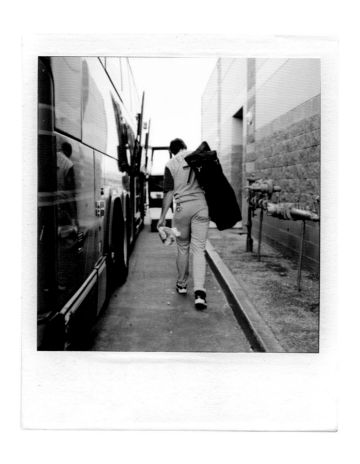